P9-DGS-847

SILENCE & SOLITUDE

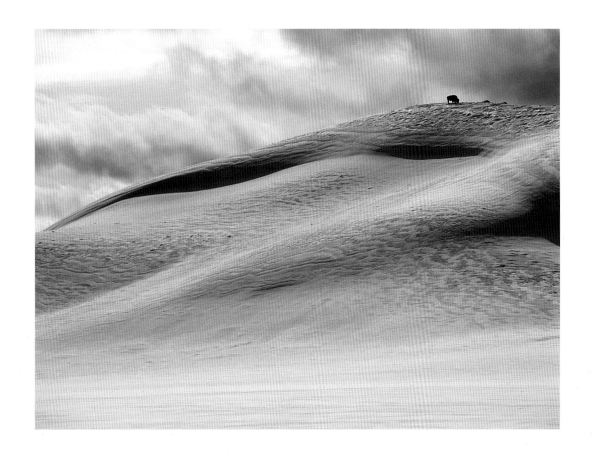

YELLOWSTONE'S WINTER WILDERNESS

by Tom Murphy

FOREWORD BY TIM CAHILL

RIVERBEND PUBLISHING

A NOTE ON WINTER IN YELLOWSTONE NATIONAL PARK

YELLOWSTONE'S WINTER ENVIRONMENT CAN BE EXTREME. Planning and foresight are required to enjoy the park safely. For your own safety and to avoid stressing wildlife, obey park regulations and do not approach wildlife. Do not travel off the boardwalks in developed geothermal areas. Obtain a park permit for overnight backcountry trips. To learn more about park regulations and winter in Yellowstone, write to the National Park Service, P.O. Box 168, Yellowstone National Park, WY 82190-0168, or call 307-344-7381, or visit the web site at www.nps.gov/yell. For guidebooks and other interpretive material on Yellowstone, contact The Yellowstone Association, P.O. Box 117, Yellowstone National Park, WY 82190, phone 307-344-2293, www.yellowstoneassociation.org.

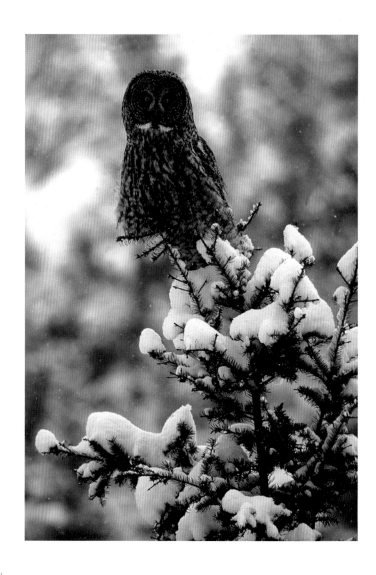

Copyright © 2002 by Tom Murphy
Published by Riverbend Publishing
Helena, Montana

3 4 5 6 7 8 9 0 SI 06 05 04 03 02

All rights reserved. No part of this book may be reproduced, stored in a retrieval system, or transmitted in any form or by any means without the prior permission of the publisher.

Design by DD Dowden.

Printed in Korea.

ISBN 1-931832-00-5

CIP information is on file with the Library of Congress.

For book orders and other information, contact Riverbend Publishing, P.O. Box 5833, Helena, Montana, 59604, call toll-free 1-866-787-2363, or visit the web site at riverbendpublishing.com.

2nd Printing

Great gray owls are crepuscular and nocturnal hunters. They are difficult to find but relatively tolerant of owl-watchers. Most of Yellowstone's great grays migrate to lower elevations in the winter but some stay year round. I had never seen or heard of a great gray owl when I saw this one on Blacktail Plateau twenty-three years ago. Fortunately I did not have to know what it was to marvel at it in the gently falling snow.

TITLE PAGE: *The high interior plateau of Yellowstone in Hayden Valley receives some of the heaviest snowfall of the park. The prevailing southwest winds blow the snow off the ridges and deposit it in deep drifts on the leeward slopes and drainages. Bison make trails through or around these drifts to reach the wind-exposed grass on the ridgetops.*

FOREWORD

"DON'T YOU THINK this idea is," I asked gently, "oh, vaguely suicidal."

My thrifty photographer friend, Tom Murphy, wanted to ski across Yellowstone National Park: a two-week backcountry ski expedition where there would be little or no possibility of rescue in case of an accident or an unforeseen emergency. He wanted to slog through a country noted for 50 degree below zero temperatures and blinding blizzards and snow 20 feet deep in order to take pictures. Tom is not a high tech guy and owns none of the latest warmest gear. It seemed to me that his cameras would freeze up, along with his fingers, and hands and perhaps his entire body, and that it was possible he might very well die in the name of photography, which sounds noble enough from a distance, but moronic when the potential victim is a friend. It was an impossible trip.

In order to navigate the country, for instance, one would be obliged to cross rivers fed by hot springs, rivers that consequently did not freeze and ran waist deep in the shallow sections so that it is necessary for a traveler to strip from the waist down, shoulder pack and skis, then ford the river, half naked, in the freezing cold, through the near-frozen water. Tom had just asked if I wanted to come with him—this was in back in 1985—I said, "uh, no."

In fact, no one else, not a soul, wanted to accompany Tom, which I thought ratified my good sense. But Tom Murphy is a man not easily dissuaded and—I still find this remarkable—he went by himself. Alone, wearing cheap dress socks under cheap leather boots. And he made it, right on schedule, though he lost ten percent of his body weight in 14 days.

Not only did he successfully navigate the park, he managed to bring back photographic images of Yellowstone's backcountry that both moved and inspired me. Tom skis in or across the park every year now, and these days often has one or two companions: hard core outdoors folk and backcountry rangers mostly. Tom's photos can be seen in local art galleries as well as in various regional and national magazines. Sometimes he gives slide shows. These are photos that mirror a man's passion, and I know of nothing like them anywhere. More often that not, the image itself tells a story.

This is because Tom, who has been a guide in the park for two decades, knows the flora and fauna and the natural rhythms of the place in the way that he knows the beating of his own heart. Walking with him through Yellowstone on a summer's day is an education: he can tell you what this flower is, why that coyote is leaping, where the wolves den, and what the bears are eating. Consequently, his photographs are not simply stunning or striking: they are also knowledgeable and even wise.

For the record, I need to say that Tom is also the world's most "frugal" outdoorsman: his pack is 20 years old, as are his skis, and he wears thin red dress socks under his old leather boots, socks that, he is

proud to say, cost him 50 cents a pair. But his gear does the job. He gets across the park in the winter, something few of us could accomplish. In the same way, his cameras are simple: he is concerned with composition and light and information that tells a story. That's all. And that's more than enough.

Tom Murphy goes out in the winter in his silly red dress socks and he brings back these wondrous, these stupendous images. This book is the closest most of us will get to a backcountry ski trip through Yellowstone. It is a fine thing to have Tom Murphy as our guide. He is a passionate naturalist, an artist of major distinction (as anyone can see paging through this book) and, as it turns out—red dress socks notwithstanding—a man not nearly as suicidal as I once imagined. Sartorially challenged maybe, but not suicidal.

Tim Cahill,
Livingston, Montana

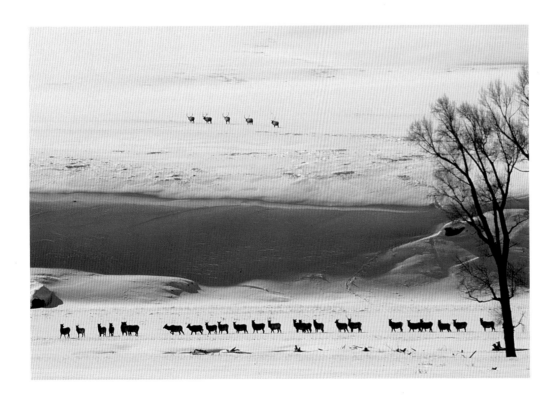

Mature bull elk generally segregate themselves from the cows, calves, and young bulls throughout the year except for the month or so of mating season in the fall. It was unusual to see big bulls near other elk in February. I think they just happened to be nearby, each group moving to separate destinations.

INTRODUCTION

WE ALL SEEK PLACES THAT COMFORT US AND TEACH US about what we feel is important. These places inspire our creativity and hopes and connect us with the universe. We need these places for the health of our spirit, and we have an obligation to protect and preserve them. If a place nurtures life, freedom, and beauty, it is invaluable to everyone. We all benefit from it even if we never visit it. Yellowstone National Park is such a place.

Yellowstone is particularly powerful because it is alive with the nearly infinite possibilities of the natural world. It is a land formed by fire and ice. Sometimes things happen here very slowly, measured in geologic time, and sometimes changes come in an instant.

One of the primary aspects of Yellowstone's winter is how quiet it can be. The silence is the silence of strength, the silence of power, the silence of endurance, the silence of patience, the silence of waiting, and the silence of expectations. The overall silence is so complete that you begin to hear things.

You hear a raven's wing beats above Swan Lake Flat.

You hear coyotes singing a half-mile away in the Lamar Valley,

You hear the sighing and creaking of the lodgepole pines as they are pushed by the wind near the head of Chipmunk Creek.

You hear the winter song of the dipper as it stands on its little, naked gray feet on an ice ledge beside Pelican Creek.

You hear big snowflakes rush past your ears.

You hold your breath and hear your own heart beating.

All these small sounds reinforce the silence. You concentrate to hear any other sound and there is no other sound for a long time. The summer sounds are gone. The rustling grass is covered with the muffling softness of snow. The flying and crawling insects are nearly all gone to reappear when there is more heat on the earth. Most of the birds have migrated south. Some of the mammals and all of the amphibians are sleeping under the snow.

The remaining mammals conserve their energy so they can see another spring. There is a slow, quiet seriousness in what they do here in the winter. You see very little playfulness; it is replaced by a more deliberate daily routine. To even stand in the cold consumes a lot of energy, and they all have to push snow. They push snow to eat, they push it to walk, and they push it even to lie down. If it gets too deep or it gets too hard and crusty, they may not be able to push it enough to survive until spring.

The world is simplified to its basic elements, yet it still produces enchantingly beautiful things in excess. Snow could be just a dull state of water. Instead, snow forms wild and graceful drifts, some with sharp, hard edges next to sensuous, soft curves. Some snow ripples and swirls, twisting along among grass, sagebrush, and rocks. Where there is no wind, snowstorms form humps on the rocks, logs, branches, and grass clumps. Snowfall can start on a ten-inch rock and build a pile of snow the size of a bison's head. Snow varies in size from the tiniest crystal on a pronghorn's eyelash to the giant windblown cornices on

Specimen Ridge. It maintains an infinite variability that invites me to keep watching.

I seek out the winter here because I find things that are exquisite and difficult or impossible to find anywhere else. There are little rows of frost crystals on snowdrifts that look like miniature forests, grown during the night by geothermal breathing. It is so clear I can see individual trees on the skyline of the Absaroka Mountains from ten miles away on the Mirror Plateau.

The cold air on clear mornings often produces diamond dust: tiny crystals of ice sparkling and twinkling quietly in the air around me, the crystals so small that initially I think I am imagining them.

As the temperature drops, the snow crunches and squeaks under my feet at higher and higher pitches— sort of an auditory thermometer. As it gets colder, it feels like I walk higher and higher on the snow.

Rivers and creeks, breathing clouds of steam, travel along between big, cold snowfields. They are temperate streams misplaced in an arctic setting, producing wisps and sometimes clouds of cold fog that brush white with frost crystals everything they touch.

Here most of the vegetation braces itself in brittle resistance to the winter. Endurance is the object. There is no germination. There is no growth. There is some death, but the strong plants wait. While they wait, the wind bends the living and the dead, and the snow buries some completely. Some are compressed by the weight of uncountable small flakes; some are scoured by ice crystals. Some provide meager nourishment for the animals that have stayed.

In Yellowstone you can look over a 100,000-acre plateau that is full of life and yet know you are the only person there. The first week of March 1985, I watched the sun rise over Colter Peak above the south end of Yellowstone Lake. There was no one around for miles in all directions and no one would come there for months. That winter I was the only person to travel through the southeast corner of the park. The chance to experience this level of solitude is almost impossible in our modern world outside of the nearly unlivable polar regions.

The solitude you can find in Yellowstone promotes an independence of spirit. These experiences refresh our lives, teach us self-reliance, and reveal the wisdom of the cycles of the land. By contrast, the noises and distractions of our modern world induce loneliness and isolation. A natural place of solitude gives us the opportunity to see and value our place in this world and gives us the necessary patience to wait for the unexpected.

I make these photographs because I love the quiet beauty of this wilderness. I try to share my passion for Yellowstone by these simple graphic images. I hope others feel, through my photographs, the wondrous elegance, symmetry, surprise, and power of this place.

Tom Murphy
Livingston, Montana

I was skiing one January afternoon in the Lamar Valley after a light, fresh snow. A mouse had been traveling in the fluffy new crystals on top of the old snow, apparently feeding on exposed grass seed stalks. There were several nice photographs of tracks and grass stems, so I spent quite a bit of time following these tracks for maybe an eighth of a mile. I was surprised to find this end. A hawk had seen the mouse; the mouse had seen the hawk. The mouse made a hard left and then made six jumps—and was food for the hawk. The light at this time was very poor, so I went on skiing for a few hours, watching the light. Just before sunset, I skied back and was lucky: the light provided some contrast to see the tracks better and the wind had not come up and blown them away.

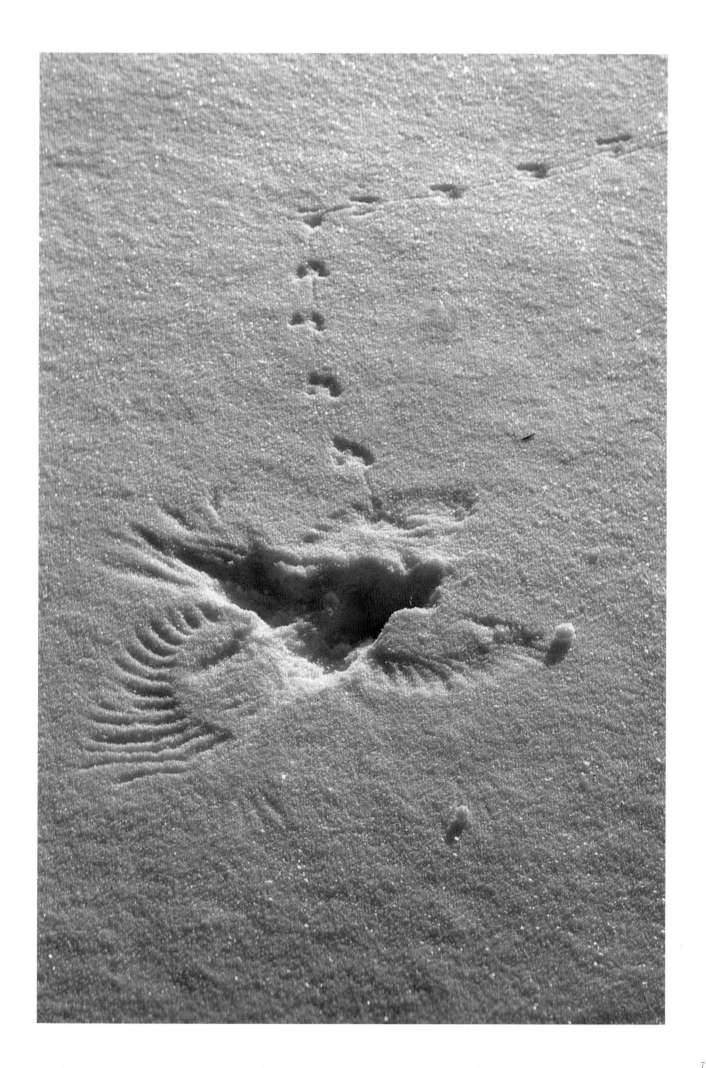

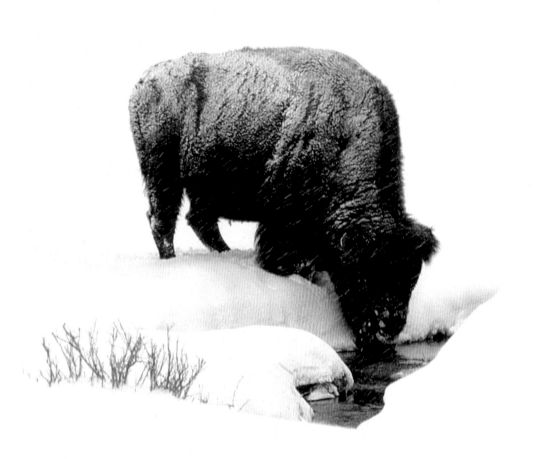

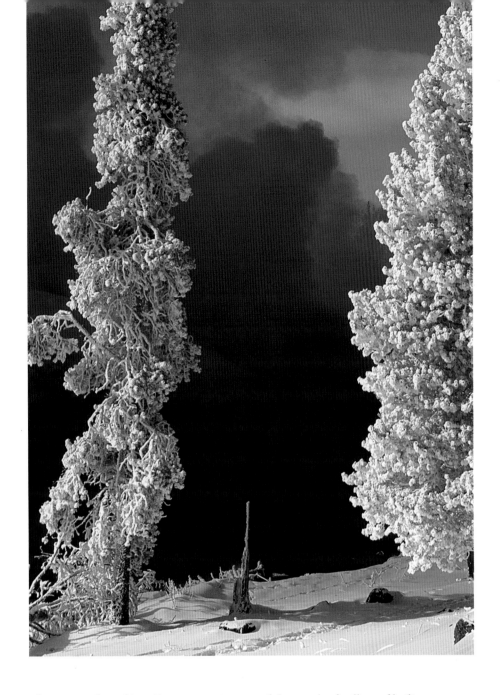

The crater of Excelsior Geyser contains tens of thousands of gallons of boiling water. This boiling water overflows down a colorful cascade into the Firehole River, helping to keep the Firehole from freezing even at forty degrees below zero. The steam from the water hides most of the surrounding landscape and coats the trees with very heavy accumulations of frost and ice. The dark blue background between the two frosted trees is the steam from the runoff channel.

By late February the snow had accumulated to a depth of three to five feet, and this bison plowed through the snow in a storm to reach the small open pool of water. Animals will eat snow for moisture, but they prefer liquid. It takes a lot of energy to melt enough snow to satisfy a bison's thirst. This image illustrates that even getting a drink in the Yellowstone winter is a deliberate, hard chore.

FOLLOWING PAGE: Yellowstone's high ridges and open valleys are subjected to a lot of wind. This ridge in Hayden Valley collects large drifts because it is on the downwind end of the valley. Every winter the drifts are different shapes but they always pile up ten to twenty feet deep below the bare ridgetop. These soft, rounded shapes remind me of frozen clouds.

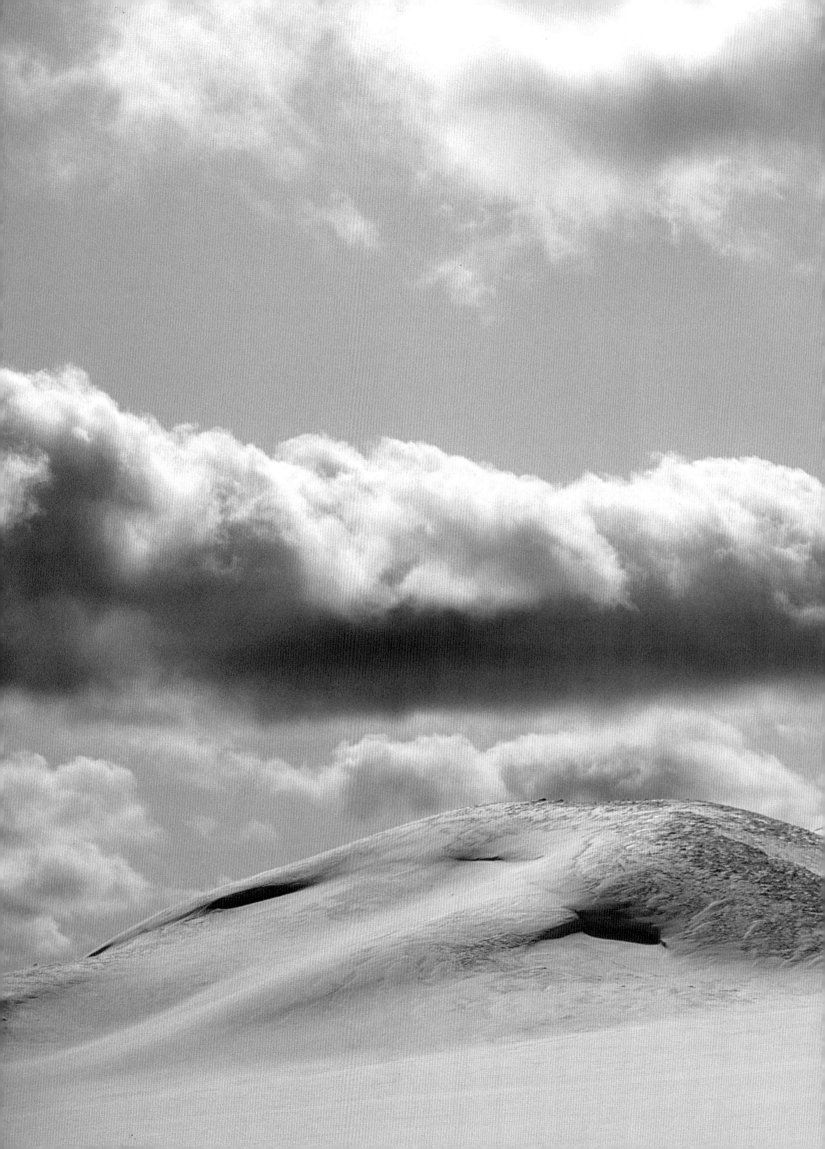

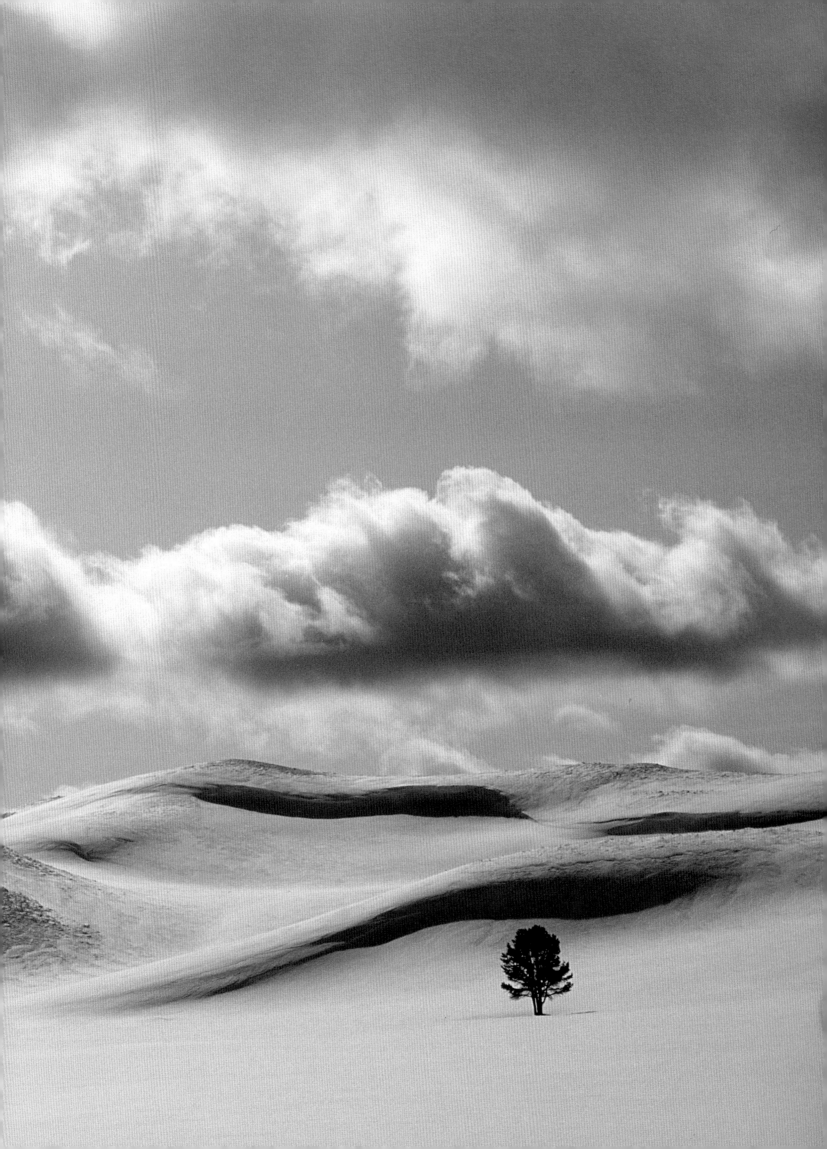

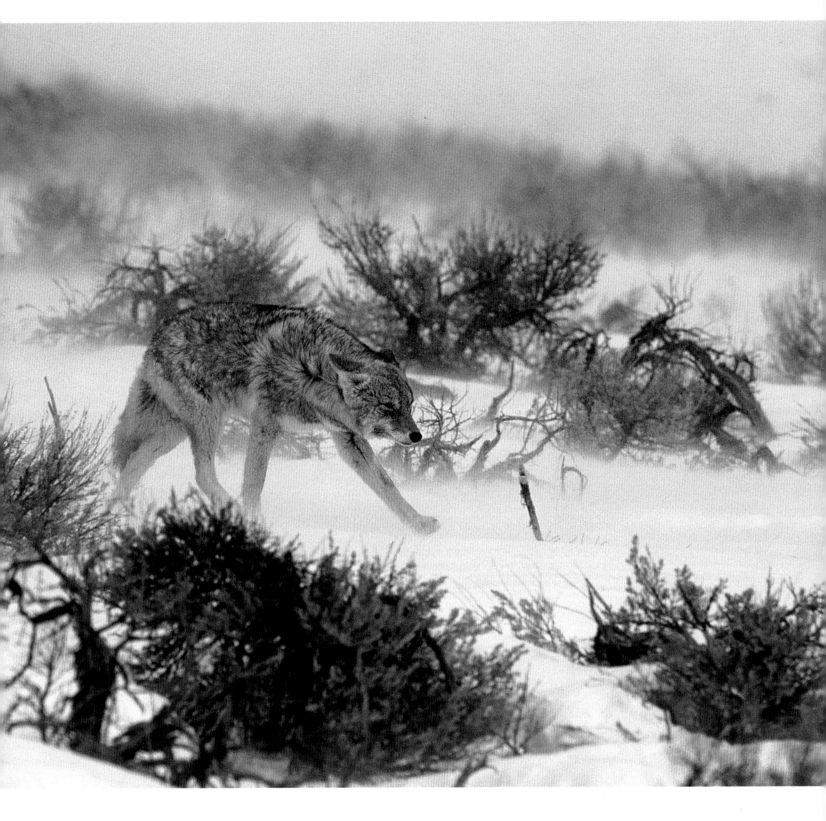

Animals must endure the cold and wind. There is some refuge in the trees, but when they need to travel in the open they must push into the wind or be pushed by the wind. This coyote was traveling across Lamar Valley through sagebrush, which didn't provide much protection. The image shows in a simple, clear way the struggle involved just to move about in this country during the winter.

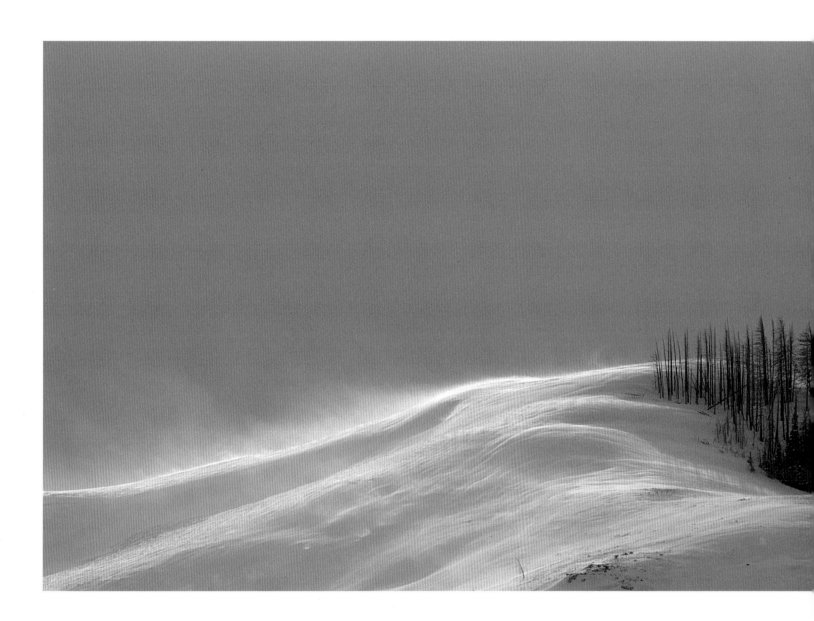

The prevailing wind on the Yellowstone Plateau is from the
southwest. When an air mass moves across the central plateau
and bumps into 9000-foot Specimen Ridge, it sweeps the top of
the ridge with high winds. Loose snow is blown spinning and
tumbling over the ridge, dropping down on the leeward side like
spray from ocean waves. This spindrift scurries over the surface
of the packed snow, swirling off the ridgetop like cloaked figures
hurrying to the quieter valley floor, then vanishing like smoke.

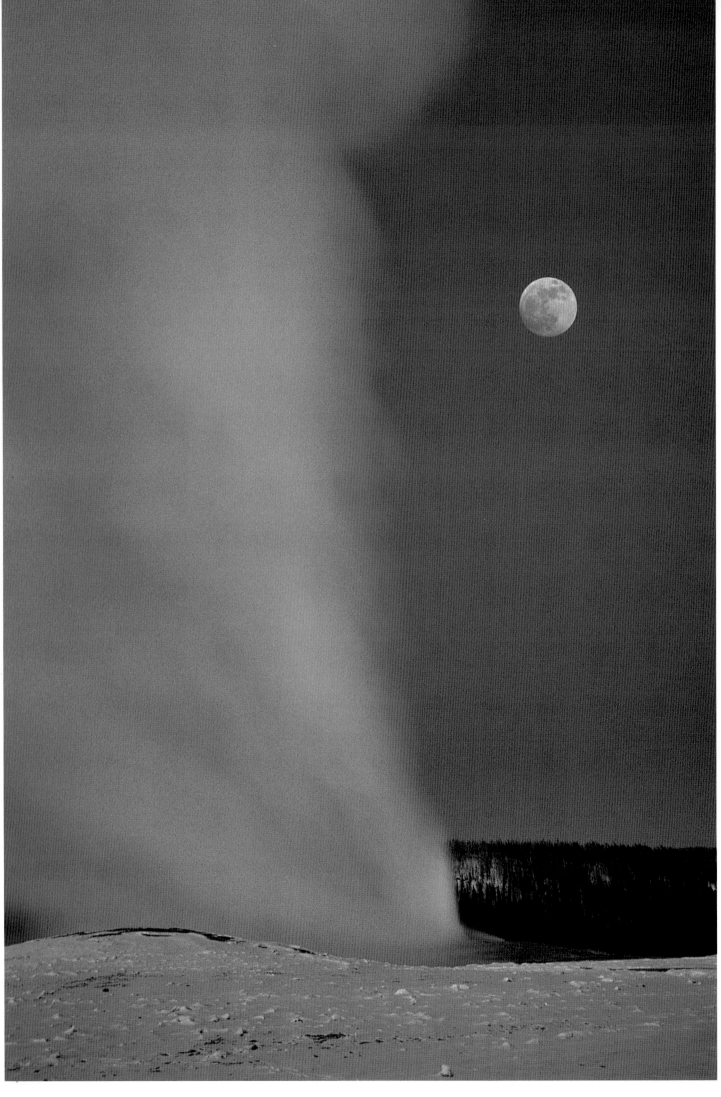

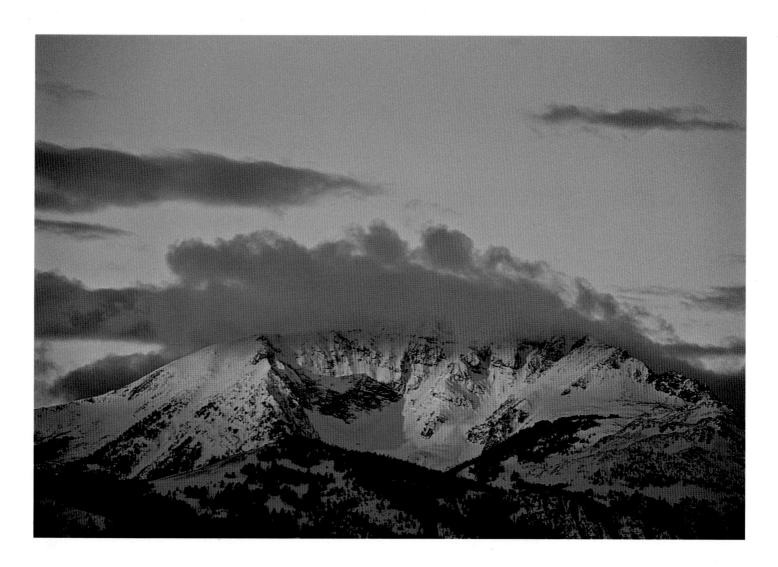

I like to include our moon in landscapes. This giant ball orbiting around us has always intrigued us. We base our calendars on its movement, and I make my winter visits to the Upper Geyser Basin when it appears full or nearly full. In the mountains, the best time to include the moon in a photograph is two days before it is full and two days after it is full. Light on the landscape needs to be bright enough to show detail, but care must be taken not to overexpose the bright moon itself.

When I stand on top of Electric Peak in the Gallatin Mountains and reach up my hand as high as I can, I touch 11,000 feet. It is the first mountain in the northwest corner of Yellowstone to see the sun every morning. It also creates its own localized weather, wrapping clouds around itself and causing a rain shadow over Gardiner, Montana.

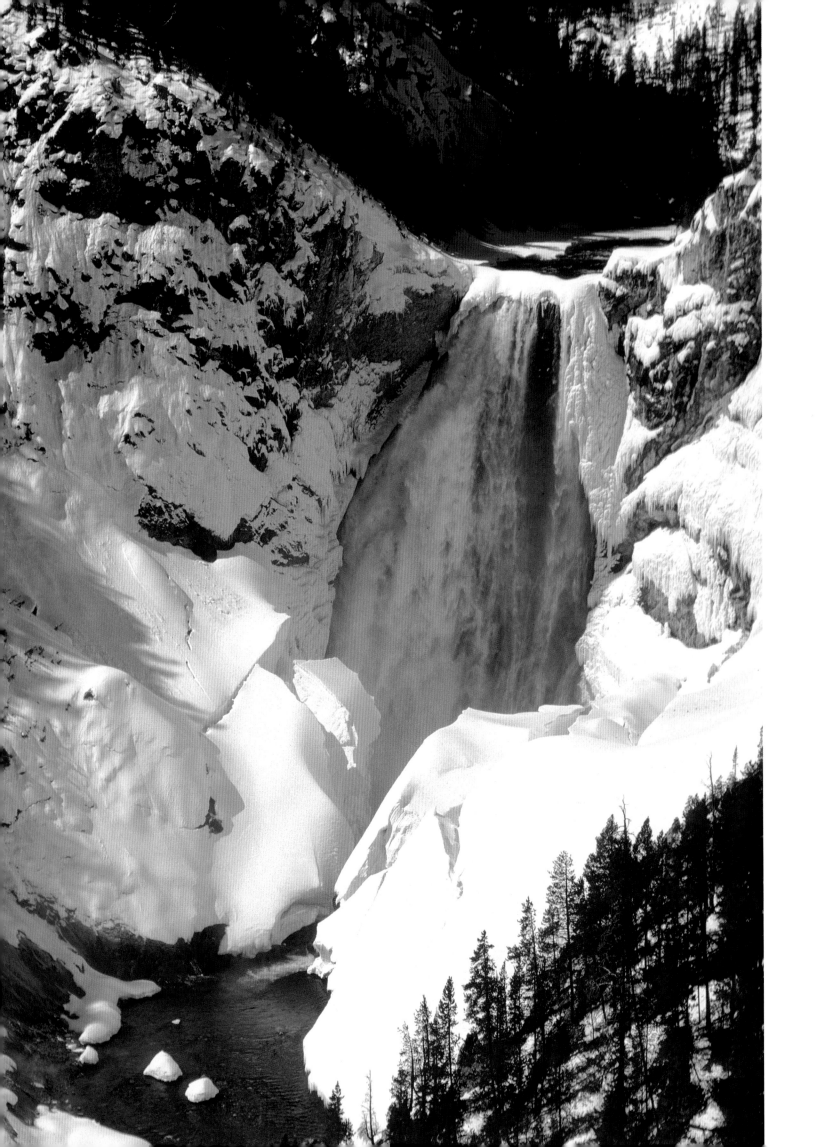

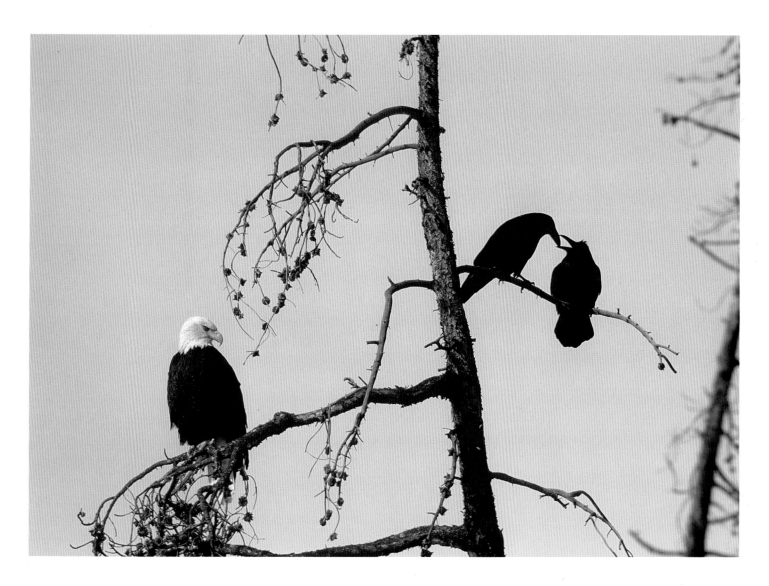

By March, winter is losing its power and ice starts to weaken and collapse. The giant ice cone that formed at the base of the Lower Falls is eroded by the same force that created it: the mist from the falling water. Hundred-foot cracks appear in the building-sized ice blocks.

We had stopped to watch a mature bald eagle in a dead pine tree. Shortly after we stopped, two ravens flew in and landed on the opposite side of the tree. Ravens are typically curious, noisy, and aggressive, and these were typical ravens. The eagle tried to pretend they weren't there. The ravens squawked and hopped around for a few minutes, then began grooming each other. They tapped their beaks together, combed each other's heads and necks, and seemed to tell each other curious or fond things. Occasionally the eagle looked at them in a nose down, condescending posture, but like those who just don't get it, the ravens ignored him, even though they had originally stopped by to see what he was doing.

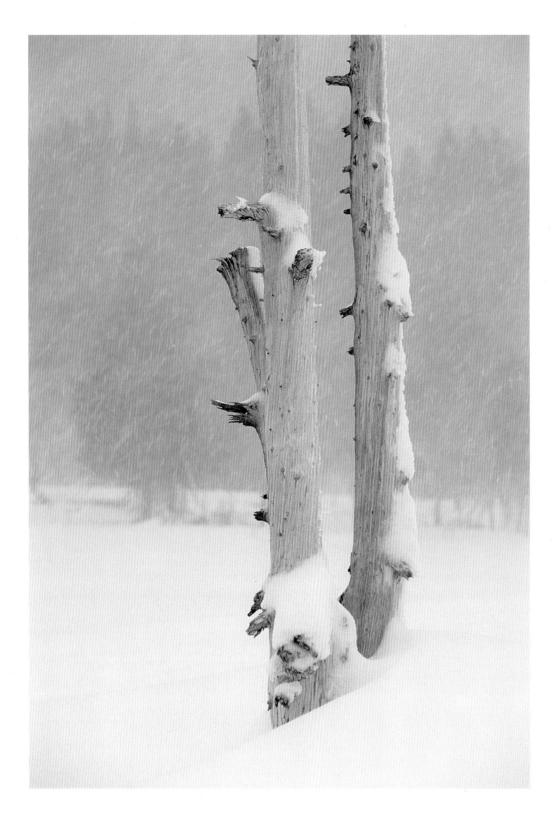

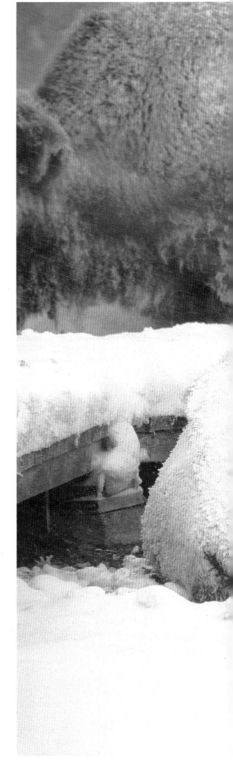

Overflow from the thermal springs around Castle Geyser flooded these lodgepole pines sometime in the distant past. The hot water killed the trees, and in time, the mineral-laden water migrated up the trees through capillary action and preserved the wood. They may stand here for hundreds of years withstanding thousands of snowstorms like this one.

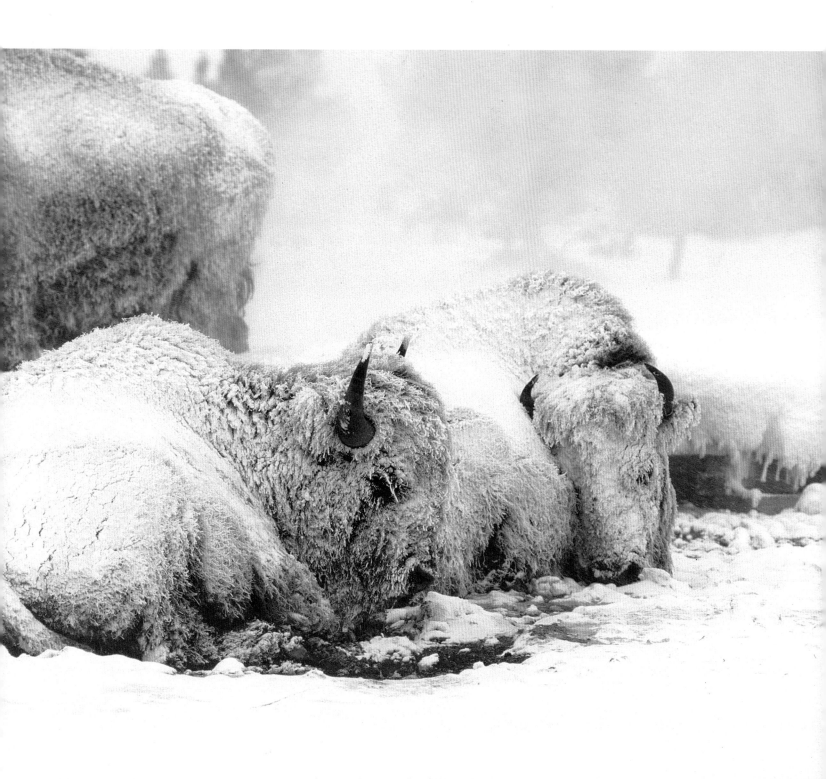

For hours these bison had been quietly lying on the warm ground next to Scalloped Spring. Steam from the spring and from nearby Sawmill Geyser had completely coated their hair with frost. Our first impulse is to think they must feel very cold, but actually this illustrates how well their hair is insulating them. The heat from their bodies does not escape through their hair far enough to melt the frost, but notice their warm horns are bare.

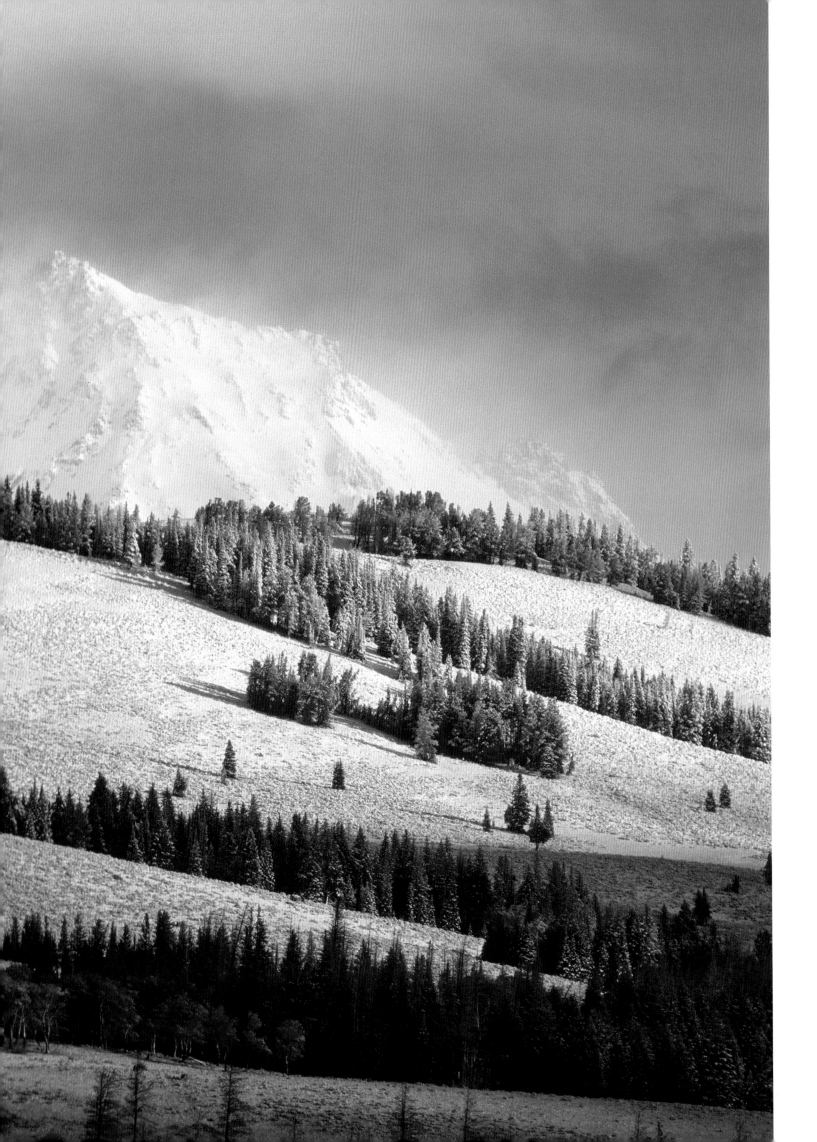

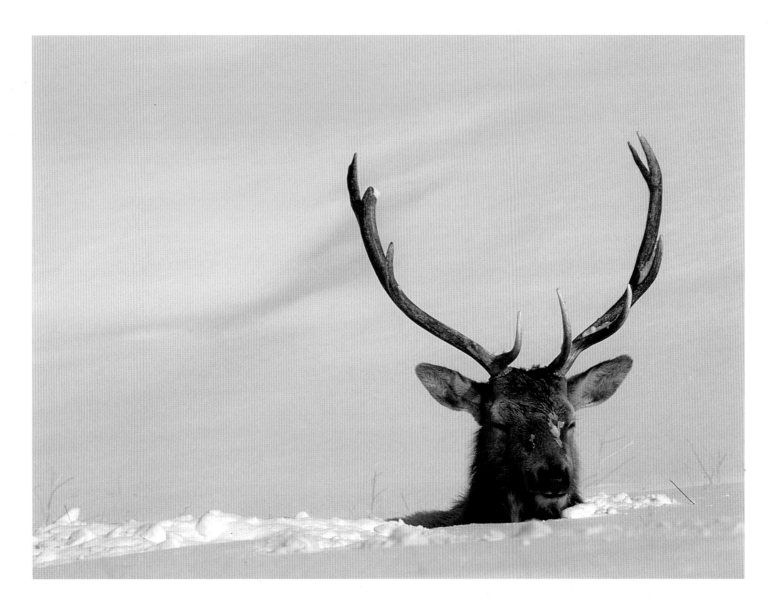

The massive shoulder of Electric Peak is softened by early morning fog and blowing snow. The fresh snowfall on the meadows and trees of the lower ridge make a nice contrast to the hard textures of the higher mountain. These two very different environments appear compressed together by looking at them through a large telephoto lens from Swan Lake Flat.

This bull elk was dealing with a difficult situation. Deep snow is hard to negotiate, so he bedded down to rest. Fortunately, the snow was fluffy and loose on the top, and it was a beautiful, sunny, winter day on Blacktail Plateau.

Winter light in Yellowstone is almost always clear and blue cold. If there is any warm light, it is very brief at sunrise and sunset. There would normally never be a reason to stop for this forlorn-looking lodgepole pine killed by the North Fork Fire of 1988. One morning before sunrise I was watching steam from Calcite Springs drift through nearby trees. The sun came over the ridge and lit up this little frosted tree along with the top of the snowdrift. Then the sun brightened everything around it, and in less than one minute this magical, golden tree once again became a nondescript stick.

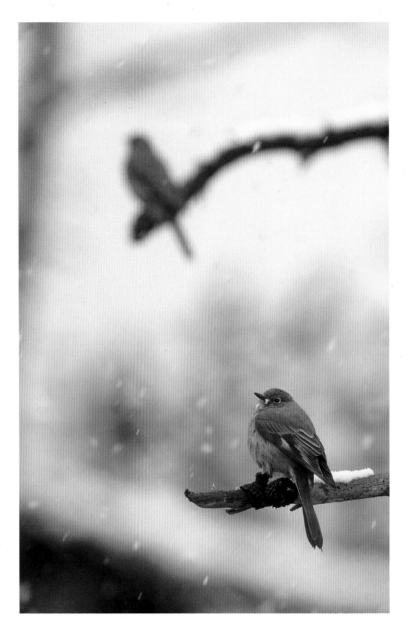

Townsend's solitaires are small, year-round residents of Yellowstone. Even though they are plain gray, they are very attractive because of their graceful shape and strong, buoyant flight. These two were feeding on a snowy afternoon, fluttering back and forth from the ground to these branches, fluffing themselves up slightly because of the cold.

A heavy snowstorm like this one muffles most sounds until only two, close sounds dominate. The loudest sound happens when a big snowflake smacks your ear. The other sound is the hiss that snowflakes make as they rush past your head to the ground. Heavy snowfall can also isolate elements of a landscape that usually go completely unnoticed. These three trees became powerful figures against the yellow rock of the canyon. The diagonal lines of the falling snowflakes create texture and a sense of motion.

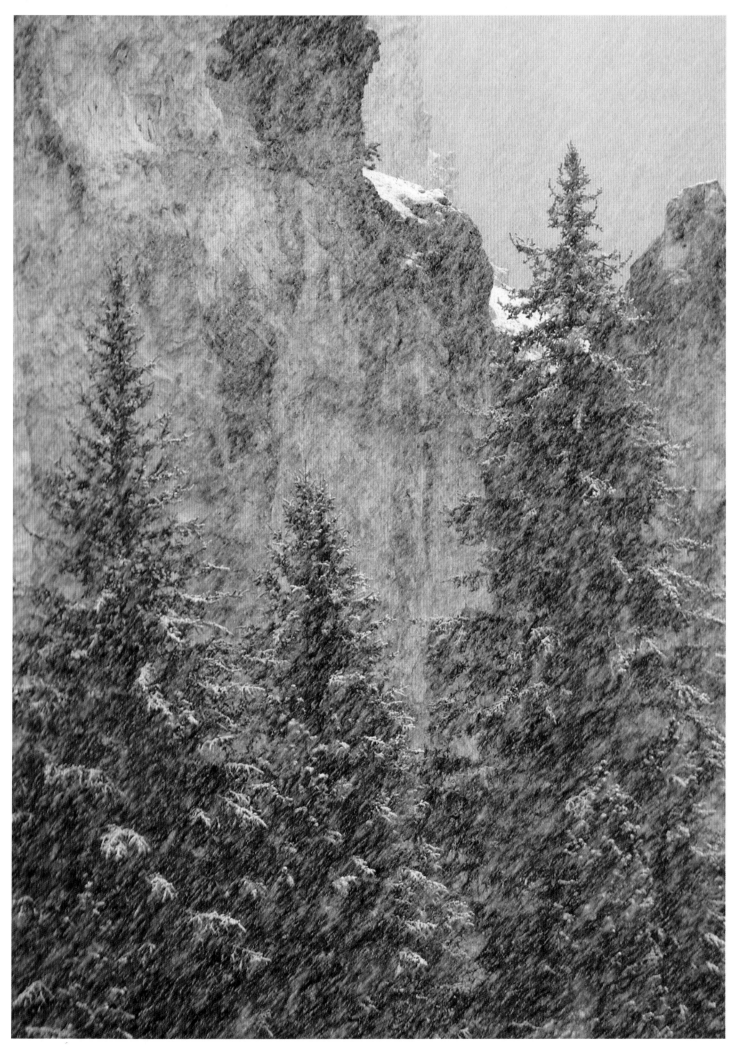

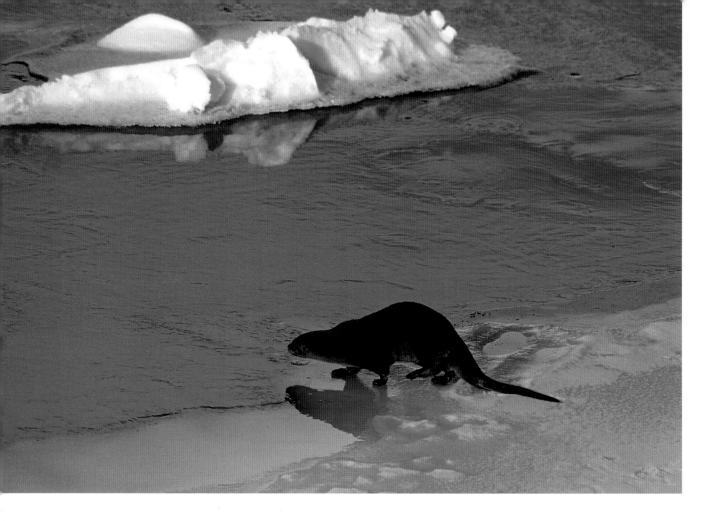

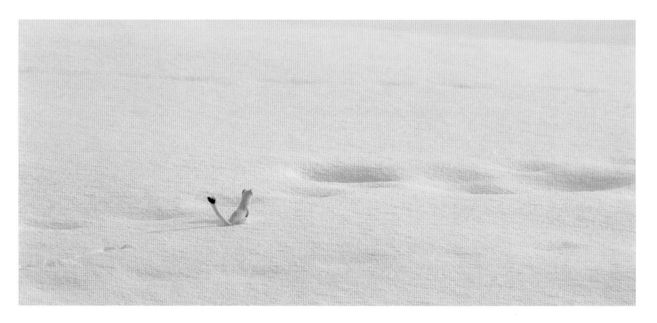

This river otter spent the winter around the Upper Falls of the Yellowstone and lived on cutthroat trout. Disappearing into the open stretch of river above the falls, she would be gone for about forty-five seconds and then surface with four to six small trout in her mouth. I was amazed she could outswim one fish, let alone hold several fish in her teeth and swim and grab others. She climbed out onto the ice and ate her catch, rubbed her face in the snow, and drank from the river before going back for another mouthful of fish.

Shorttail weasels are brown in the summer and white in the winter, when they are called ermine. Weasels are aggressive hunters, primarily pursuing small rodents. Hopping along quickly on the surface of the snow, using his beautiful black-tipped tail for balance, this weasel skittered around, looking and sniffing for lunch. This hyperactivity makes ermine difficult to find. They usually burrow into the snow and hunt the rodent tunnels along the ground, out of sight with only brief forays on the surface.

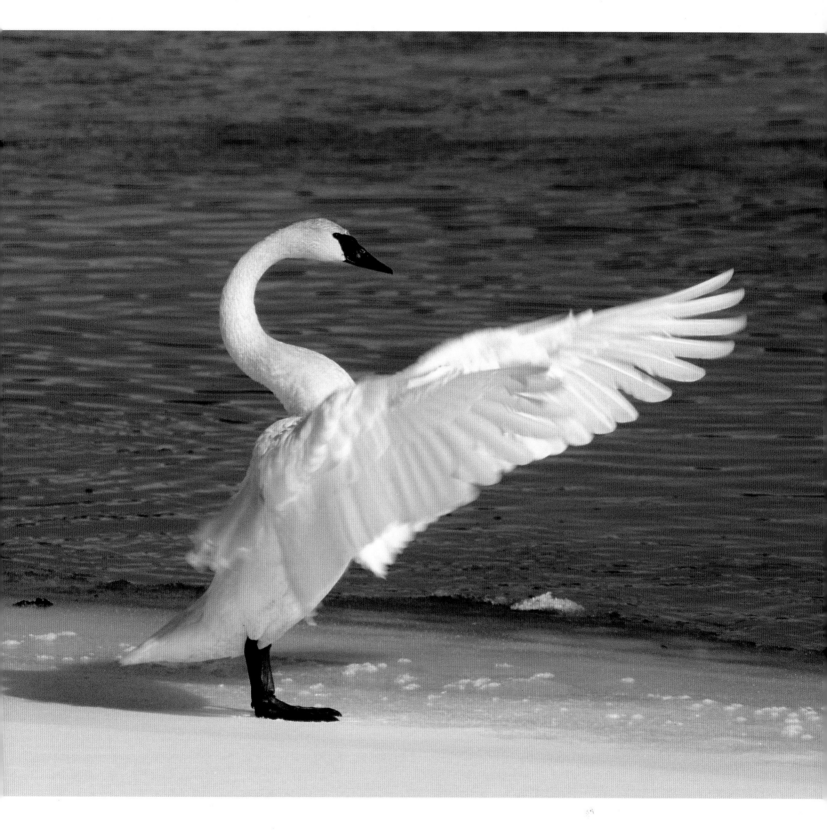

Trumpeter swans concentrate in Yellowstone during the winter because the thermals keep a lot of shallow water free of ice. Dipping their strong, flexible, snake-like necks to the stream bottom, they feed on aquatic vegetation. After they finish feeding, they usually climb out of the water and preen. They clean and comb their feathers with their beaks. Before they settle down to rest they usually raise up their head and breast and quickly flap their wings in front of them several times, possibly to rearrange their primary wing feathers.

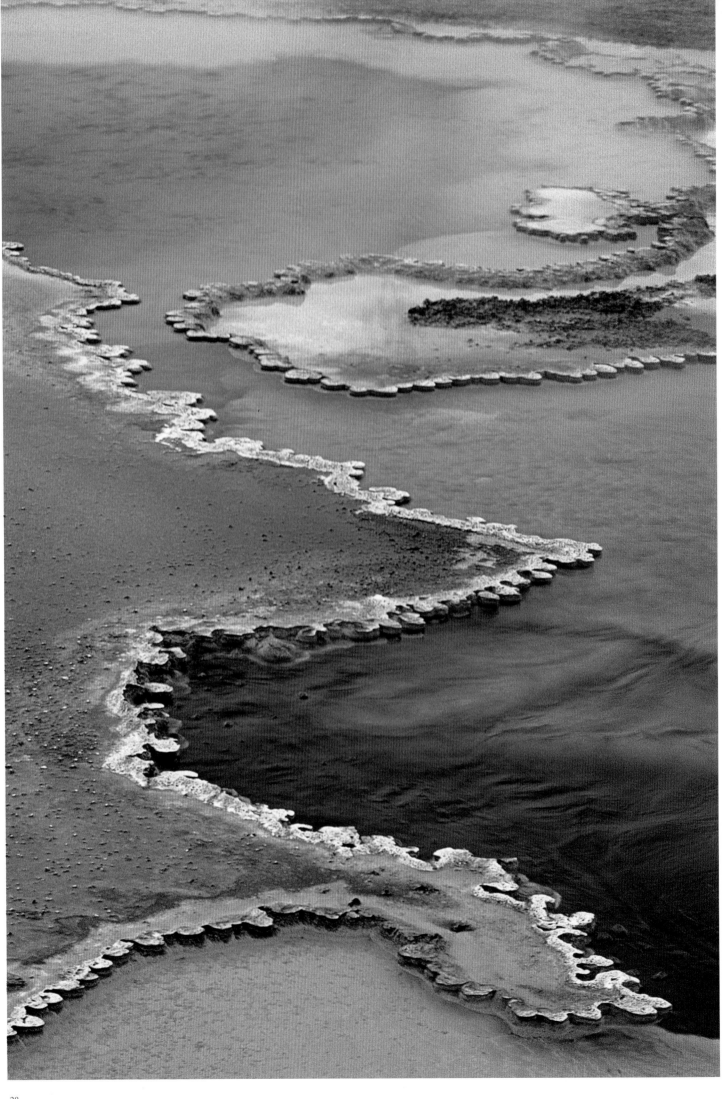

Hot springs in the Upper Geyser Basin carry dissolved silicates to the surface from the volcanic rock below. When the hot water cools and evaporates, it deposits the silica, forming geyserite or sinter. Doublet Pool creates a particularly beautiful scalloped sinter formation all around its edge. About every half-hour Doublet rises about four inches and overflows off Geyser Hill, the process slowly building its lacy collar of rock. When the pool is full, the water column bounces up and down and makes a deep thumping sound as tons of water bang against the sides and bottom of its crater. You can feel the boardwalk shake every time it thumps.

Crested Pool, next to Castle Geyser, boils constantly, producing a lot of noise and steam. In spite of all the furious activity there is little runoff. Bison seek these shallow runoff channels to soak up the steam's heat, ignoring the furious bubbling next to their feet.

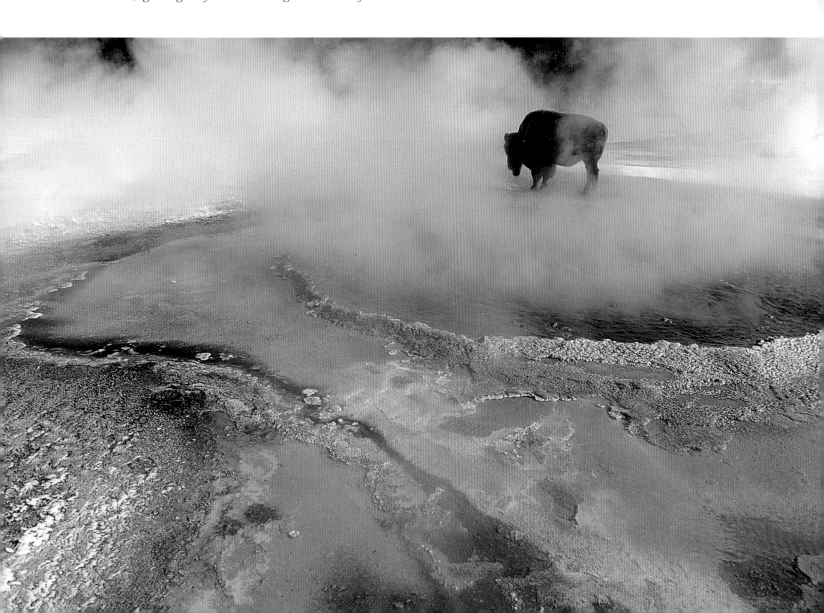

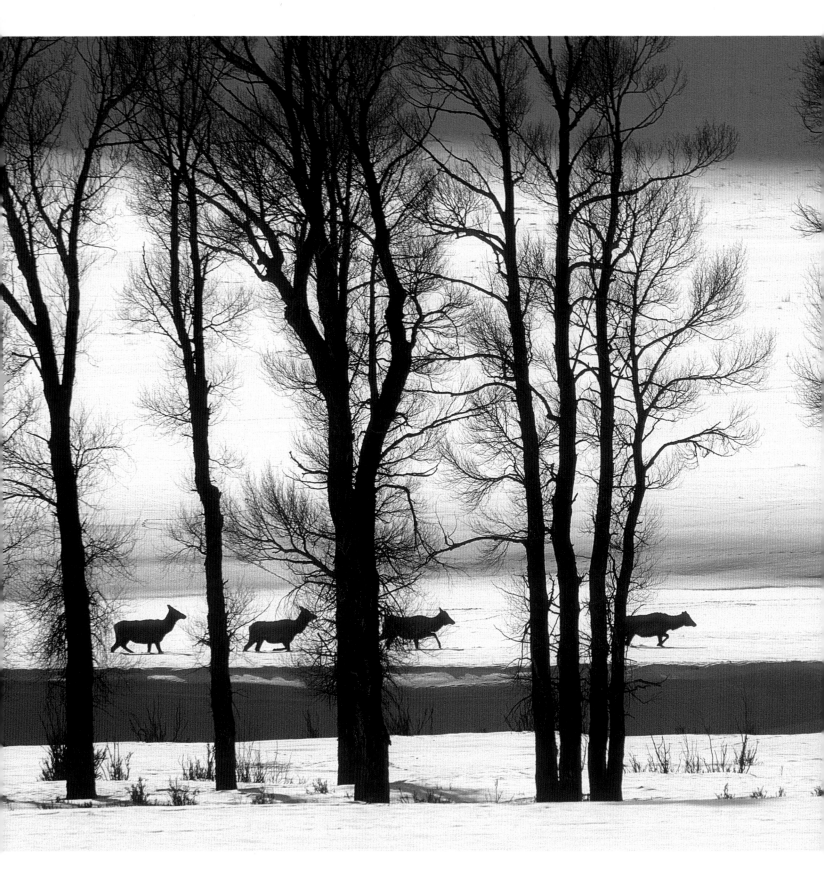

Elk prefer to travel through deep snow in single file. The first individuals break a trail and the rest follow in their footsteps. These four cows were traveling down the south side of the Lamar River to join a larger herd. I carefully timed this shot so all four are visible between the silhouetted cottonwood trees.

Warm water from the overflow of Daisy Geyser runs through this meadow and into the Firehole River. The intermittent flood of warm water carves a miniature canyon in the snowfield. When there has been little wind, the melt channel is clear, illustrated in this photograph. If there has been a lot of wind, snow bridges form over the stream, making skiing across these features a lot easier.

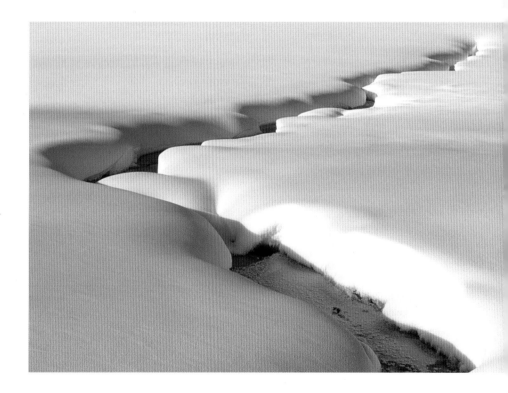

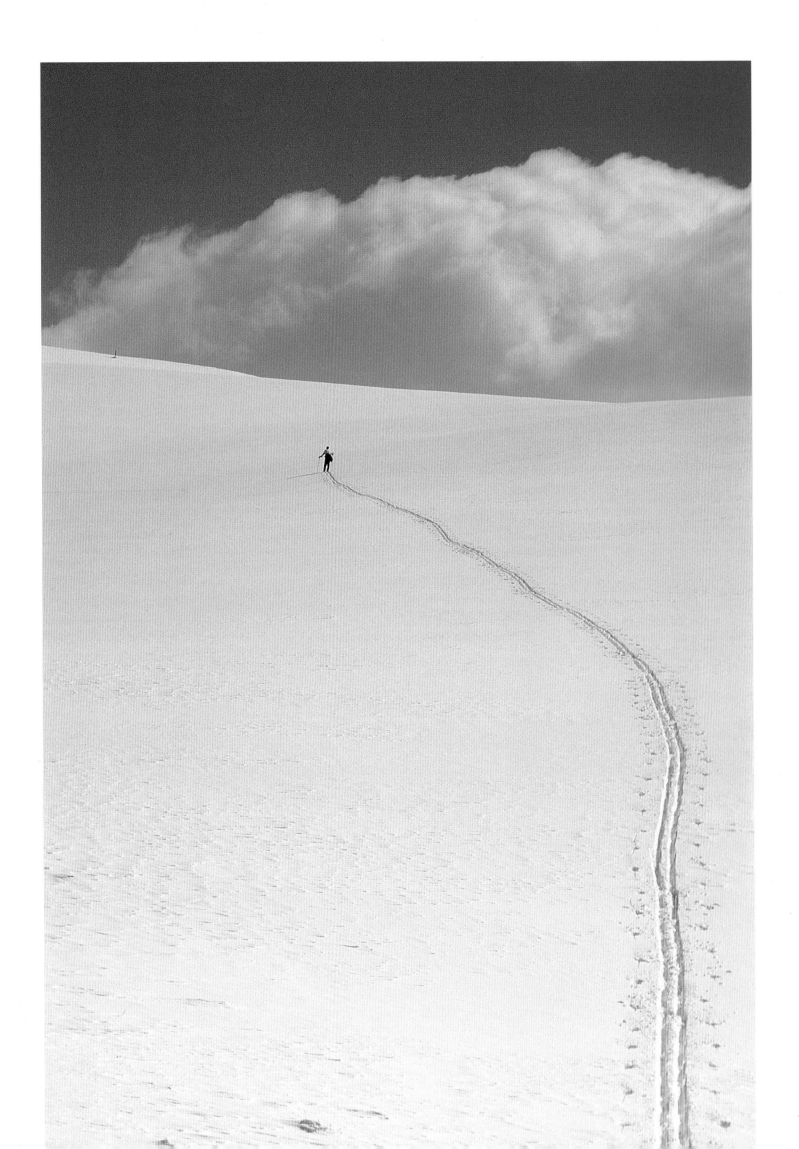

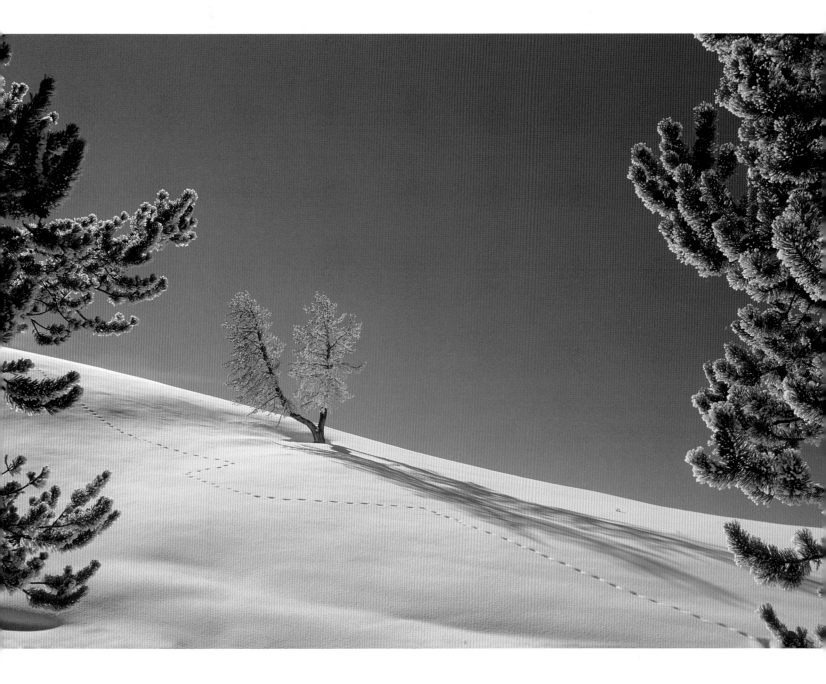

A friend and I were on a four-day backcountry ski trip in early March. We had set up our camp on the top of the west end of Specimen Ridge and were making day trips from there. This clean expanse of snow was typical of what we saw. No one else was around for miles; the weather and snow were perfect. From the top of the ridge we looked across the central plateau of Yellowstone and watched the clouds climb twenty thousand feet in the air and glide off to the east.

This dead lodgepole pine had attracted me several times over the years. This tree is so nondescript that in the summer it is almost invisible, but the snowdrift that forms around it every winter makes it stand out. This morning under a blue sky there was frost all over the tree and a beautiful set of coyote tracks stitched across the smooth drift below it.

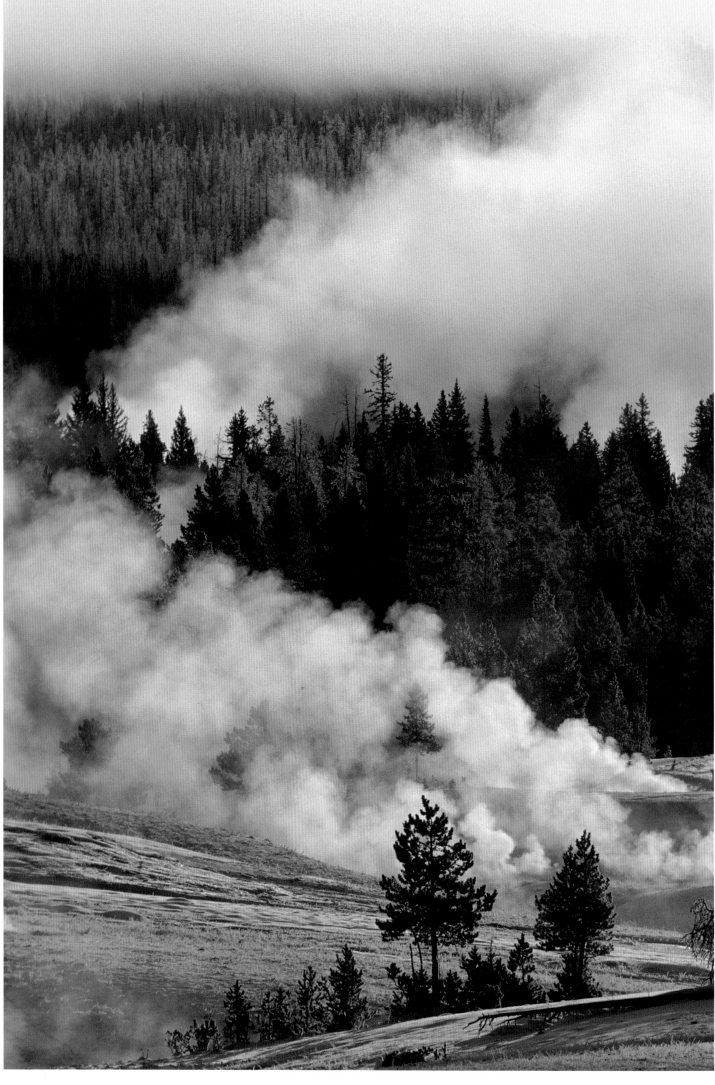

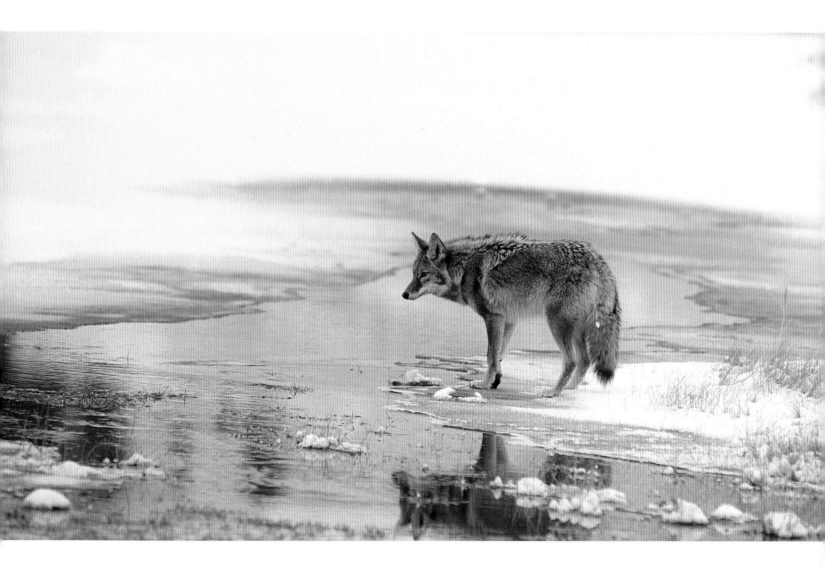

On clear mornings in the Upper Geyser Basin the steam from hundreds of thermals climbs and drifts in the trees. The landscape changes every few seconds as the steam hides and reveals different trees, snow banks, and rocks. These diaphanous veils make a normally static landscape turn into a steady show of texture, space, light, shadow, and form.

This coyote was traveling across Lamar Valley one November. She caught a meadow vole in the shallow snow, locating it primarily by sound. When she arrived at this open pond she looked at the bones of an elk on the other side. It was obvious she debated whether to detour around the pond or wade through the cold water to investigate the carcass. Gingerly and quickly, she waded across and spent the next twenty minutes chewing on some of the elk bones.

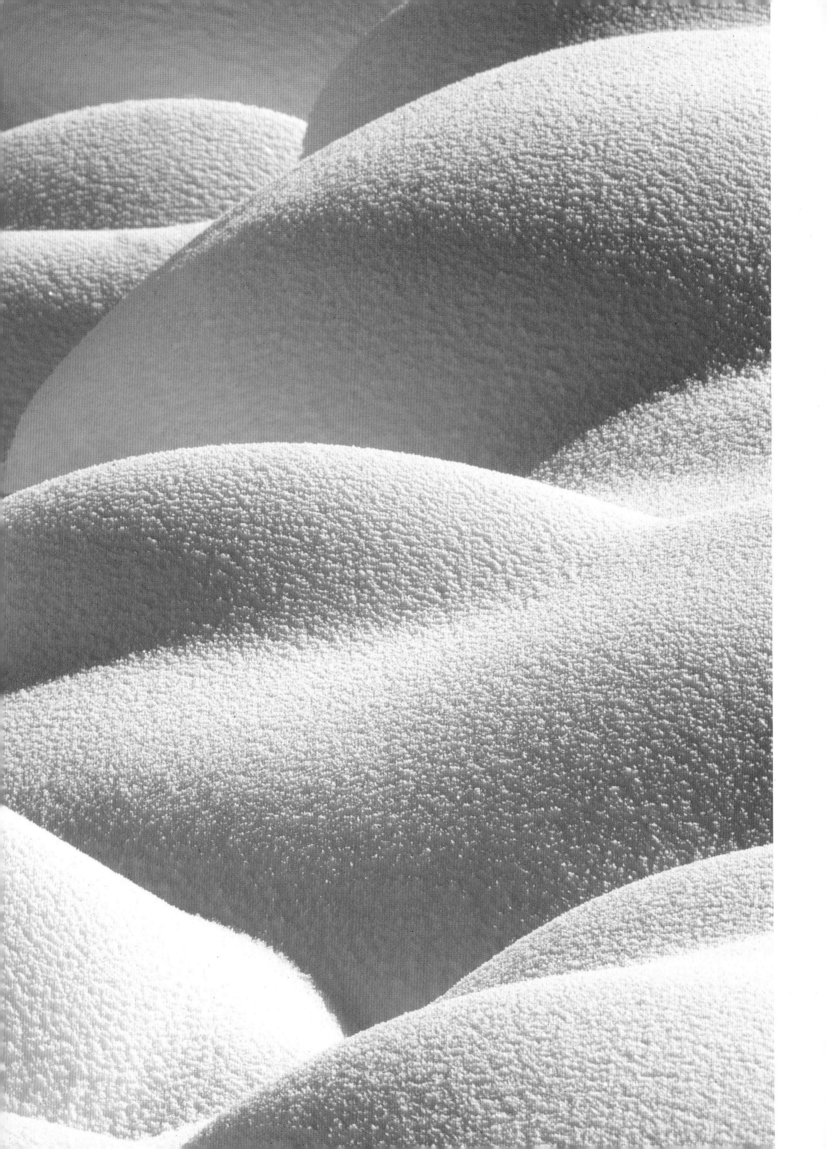

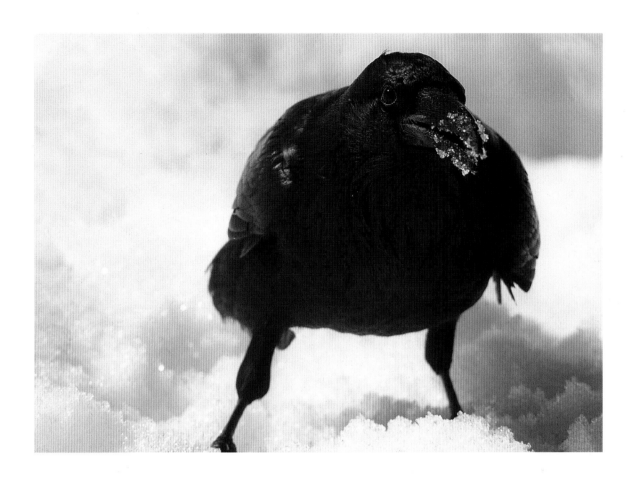

There is very little wind at this spot on Soda Butte Creek so the snow piles up on the rocks and forms snow pillows. The same rocks are always there yet the pillows are different each year and can vary a lot even from week to week. The underlying rocks are from six inches to four feet in diameter. I call this particular abstract my Norwegian beach scene.

Ravens can live almost anywhere. They do well in the subzero Arctic, in the Sonoran Desert in Arizona, and in the temperate rainforest of coastal British Columbia. They have been seen flying above climbers in the death zone above 26,000 feet on Mount Everest. This particular bird was picking through slushy snow looking for edible items from a nearby elk carcass.

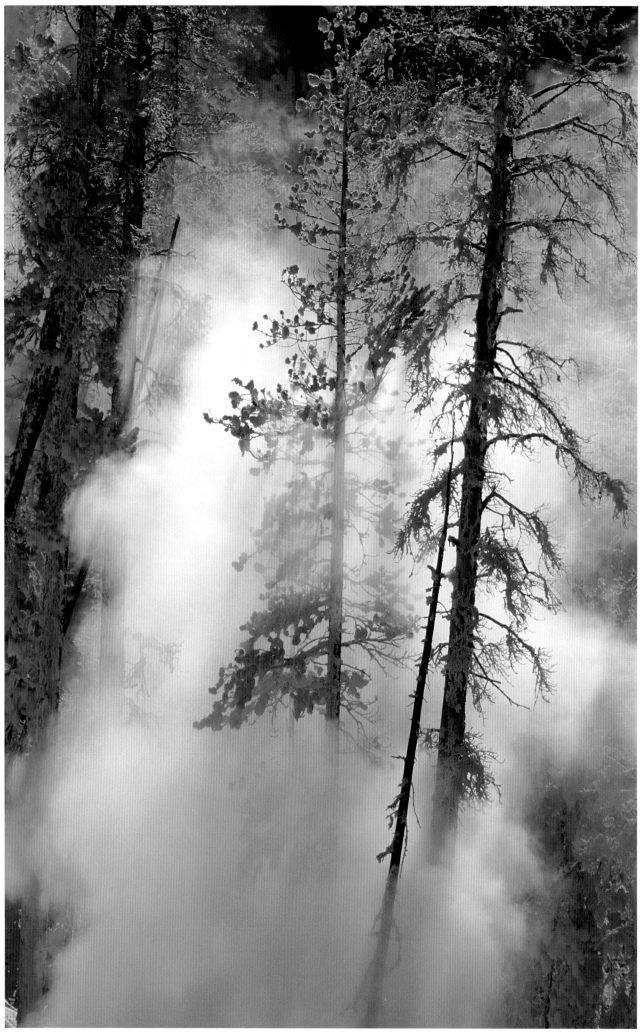

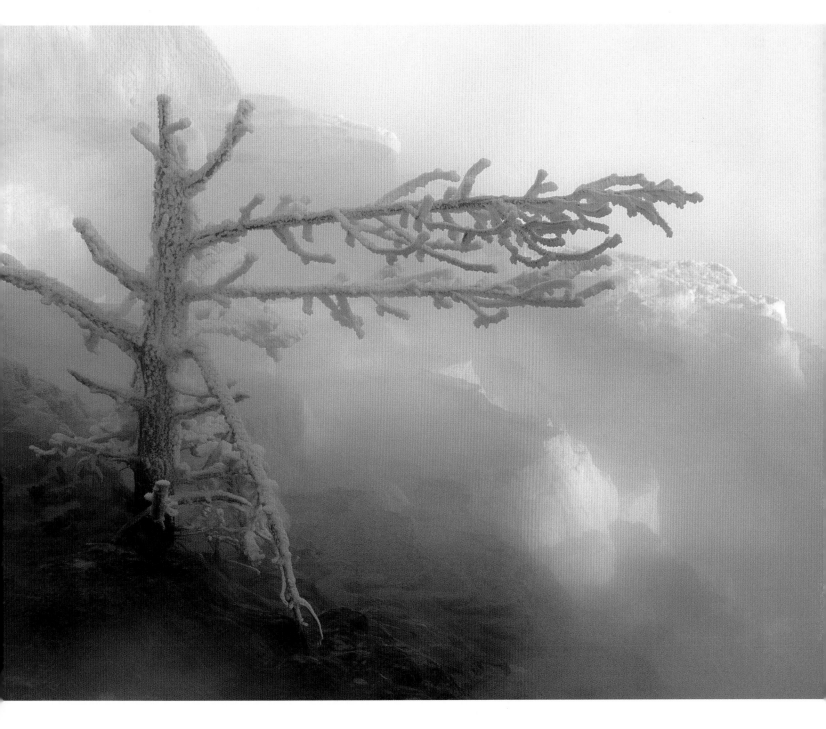

Steam rising from the Gibbon River swirls through a dense stand of lodgepole pine. When the morning sun backlit this small group of trees, the fog would sometimes glow. The contrast and shadows made the fog and light appear to come from the trees themselves as if they were ablaze with cold, white flames.

Canary Spring on the south side of Mammoth Hot Springs has been very active during the past ten years. It has built travertine formations thirty feet high and fifty feet deep. Trees like this are sometimes in the spring's way. When the hot water first finds the trees, it kills them. After the trees are dead, their branches become brittle, and winter's heavy layer of frost and ice breaks off many branches. Eventually the spring may embrace the remainder of the tree and seal it in a white stone monument.

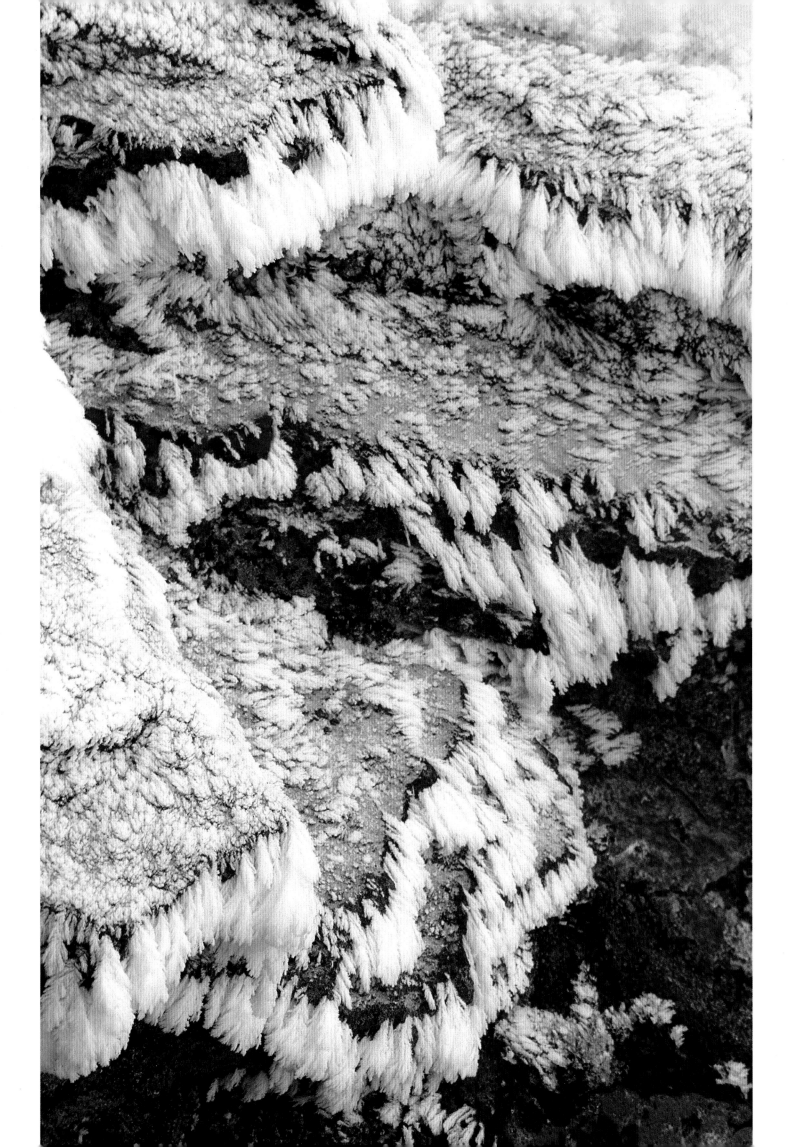

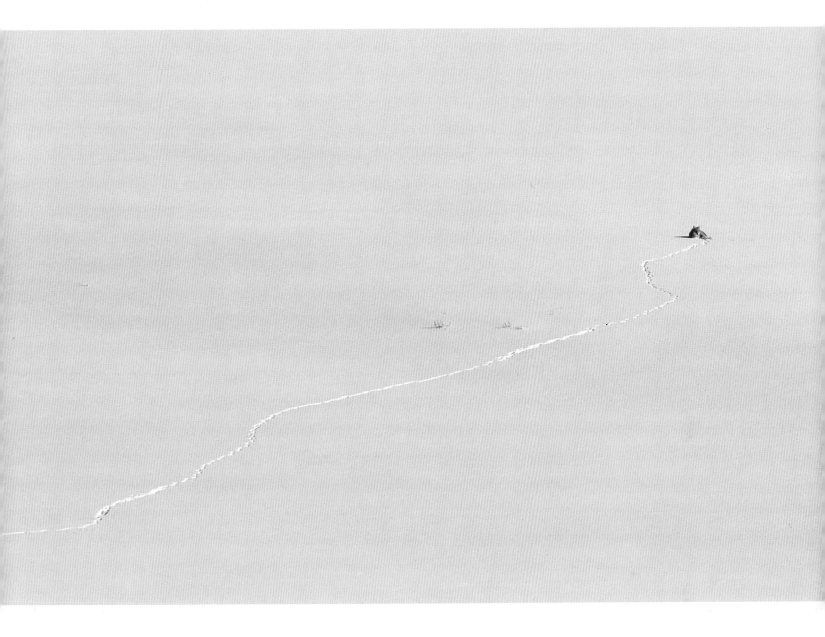

Overflow from Sawmill Geyser runs down a sinter-lined channel to the Firehole River. Cooling rapidly in the February night, the water had steamed and grown these feathery crystals on the margins of the sinter channel. The runoff channel is an old one and orange lichen has grown on the rocks, too. The long crystals grew down, each hanging from a tiny point on the rock's edge. Fluttering occasionally in the faint breeze they accumulated moisture until they became too heavy and the breeze became too strong and broke them off and blew them away.

When a coyote needs a nap it will find a place with good visibility in order to see any approaching threat. In the winter a coyote will often choose an open expanse of snow. On this quiet, clear morning there was no need to huddle out of the wind against a sagebrush, so this coyote wandered along until she decided this spot was just right. Then she tramped around several times in a tight circle, lay down, and put her tail over her nose—leaving the whole story written on the snow.

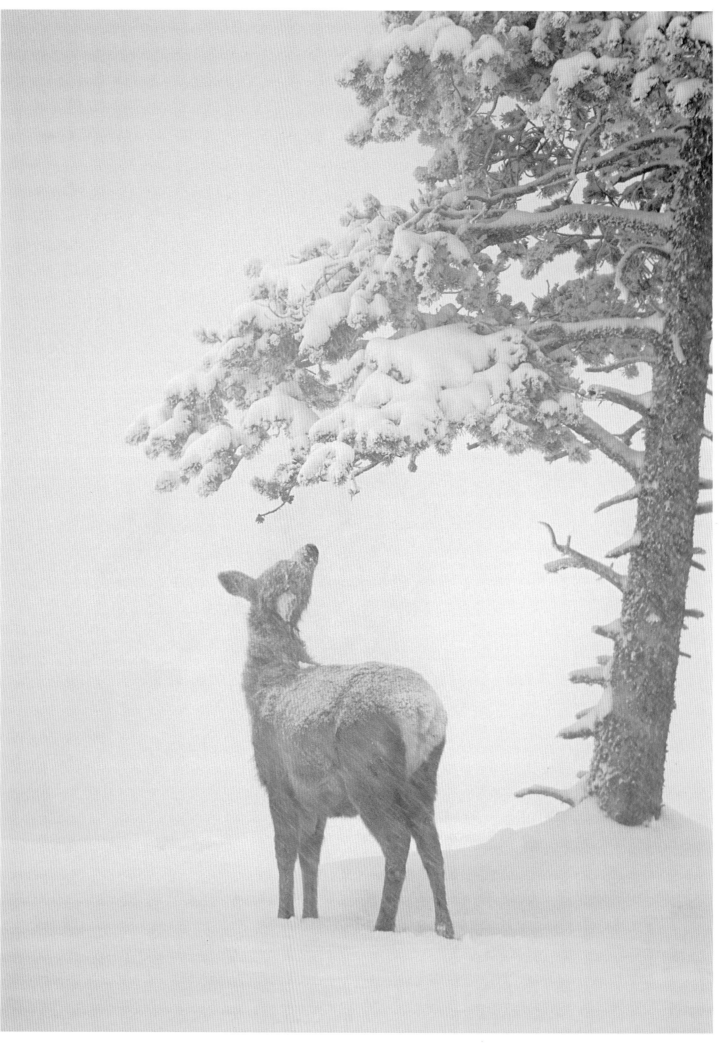

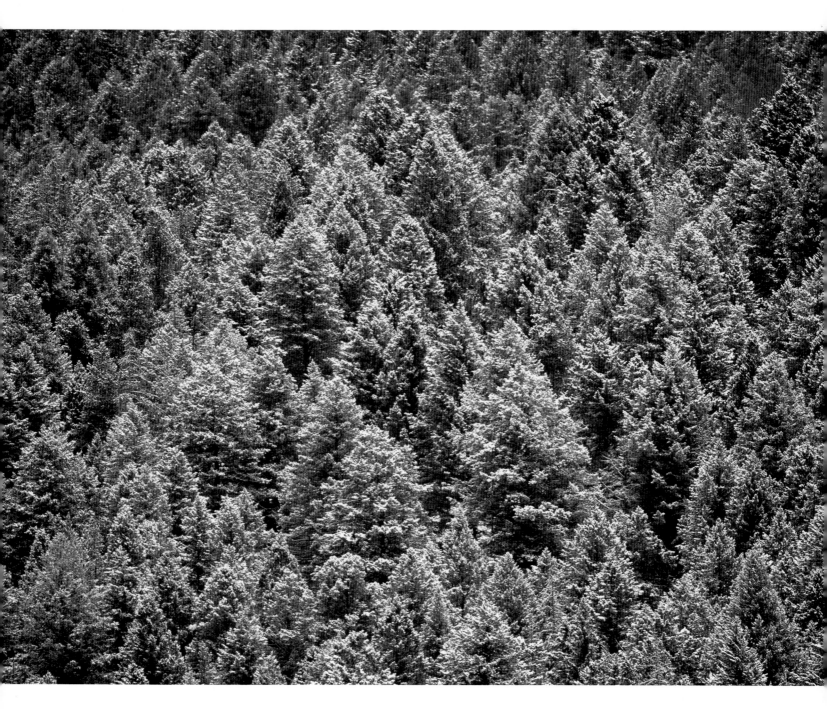

It was snowing hard. A small elk herd was slowly wandering along, finding little to eat. One calf walked toward the pine tree. I liked the shape of the tree and hoped the calf would at least stop under the left branch. She stopped and then reached up to nibble on the lowest needles. The curve of her neck as she looked into the tree is one of several nice shapes that hold this photograph together.

The most common tree in Yellowstone is the lodgepole pine. It is a fire-dependent species, which means a stand usually has to burn to regenerate. This stand of lodgepole, because of the uniform size of the trees and the dense growth, probably grew as a result of a fire. The texture from the snowfall and from the triangular shapes of the trees makes this shot interesting, while most forest images are too random and cluttered.

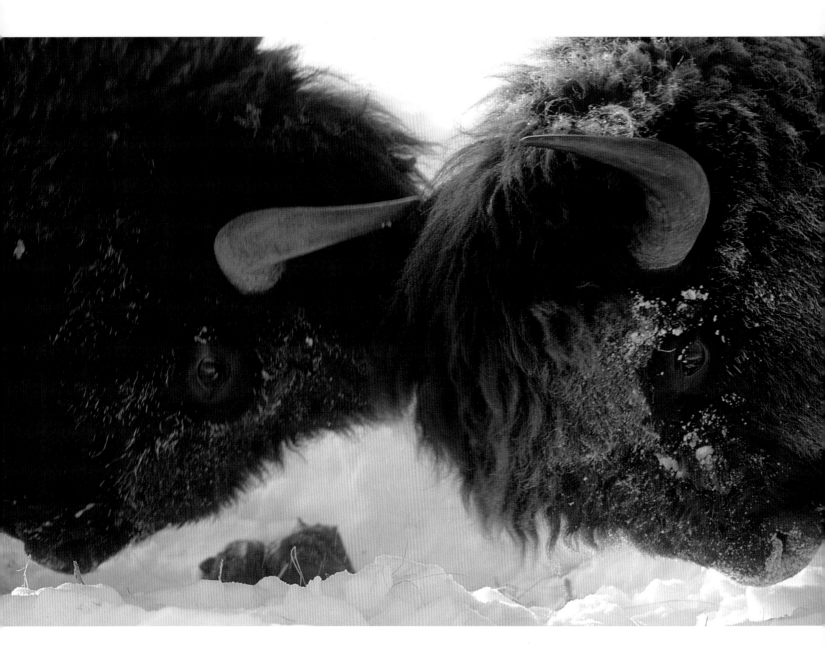

Young adult males like these two bison are usually the ones that play-fight or spar. It is a way for them to test one another's strength without much risk of injury. They are not fighting over anything, and the loser and the winner just walk away. In a serious summer fight, bison bulls make a lot of noise, producing loud, rumbling grunts and chuffing sounds. Winter sparring only produces thumps and clicks from their heads and horns bumping together, plus the shuffling sounds of their feet.

In deep winter, bison need to find areas that have shallow snow cover or abundant grass. The marsh near the mouth of Pelican Creek has deep snow, but the grass is so thick it is worth the effort to push the snow around. During the winter these stoic, patient animals plow this area over and over.

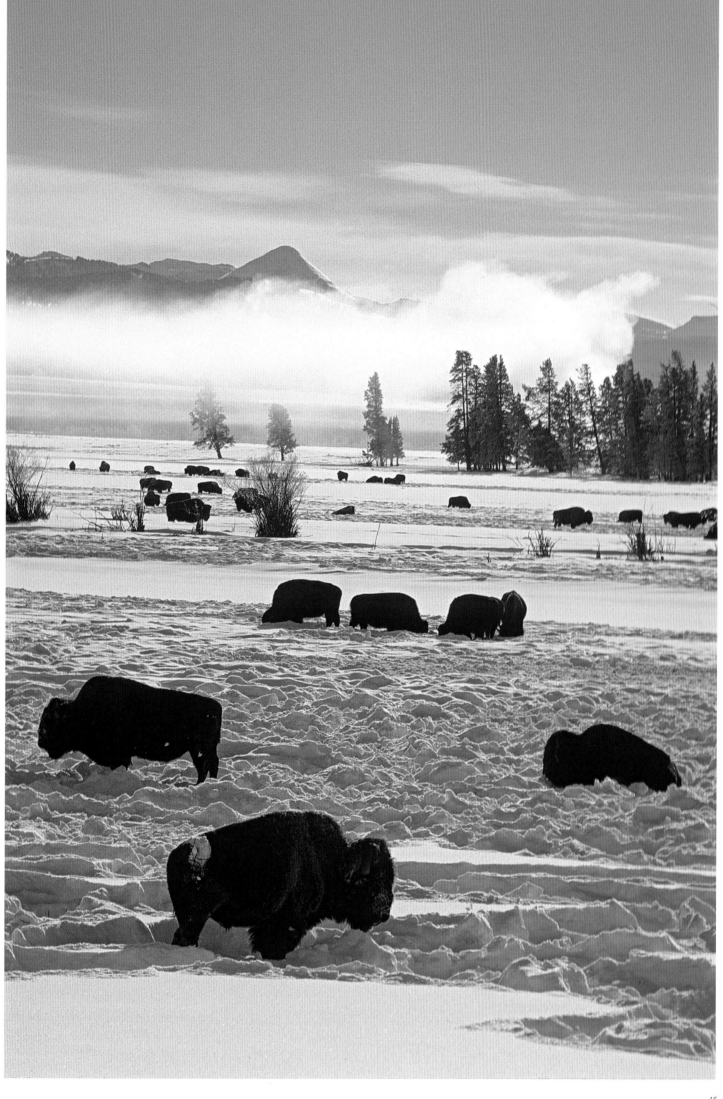

The fires of 1988 left millions of standing dead pine trees. This normal cycle in nature only happens about every hundred years. A stand of dead trees has a beauty much like an animal's skeleton. The graceful stark bones of a rib cage or articulated vertebrae are beautiful like this group of dead lodgepole pine. The smooth arcs of the trees' shadows create a nice counterpoint to the hard vertical lines of the forest's skeleton.

The reintroduction of the wolf into Yellowstone has been a resounding success. This black wolf was a member of the Leopold Pack, the first Yellowstone pack formed after the reintroduction in 1995 and 1996. Howling, listening, and watching, this wolf was trying to find the rest of the pack on the Blacktail Plateau, the center of their territory. As he moved along, it was obvious he belonged here, and I agree with others who feel the Yellowstone wolf reintroduction is one of the best wildlife success stories of the last fifty years. The howls of the wolf—deep, low, humming chants—once again carry for miles across Yellowstone.

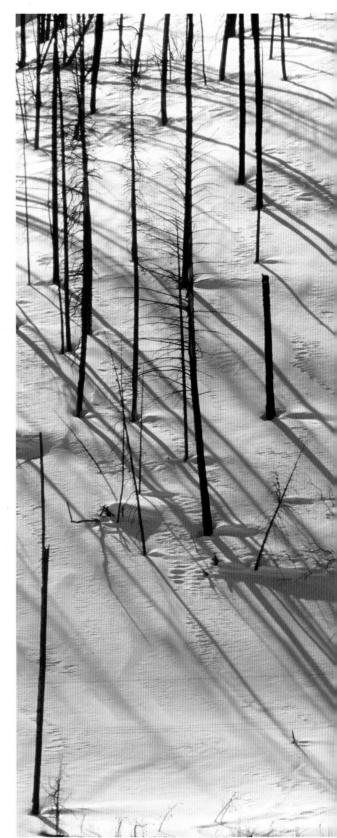

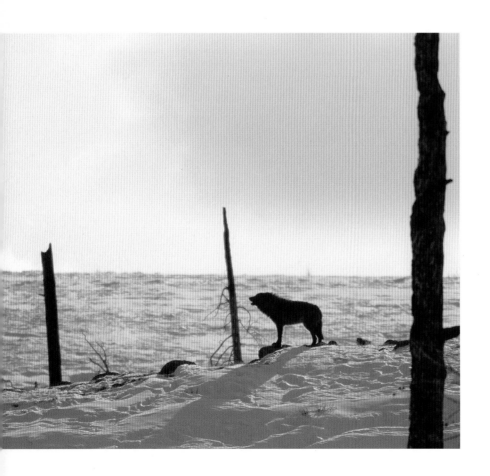

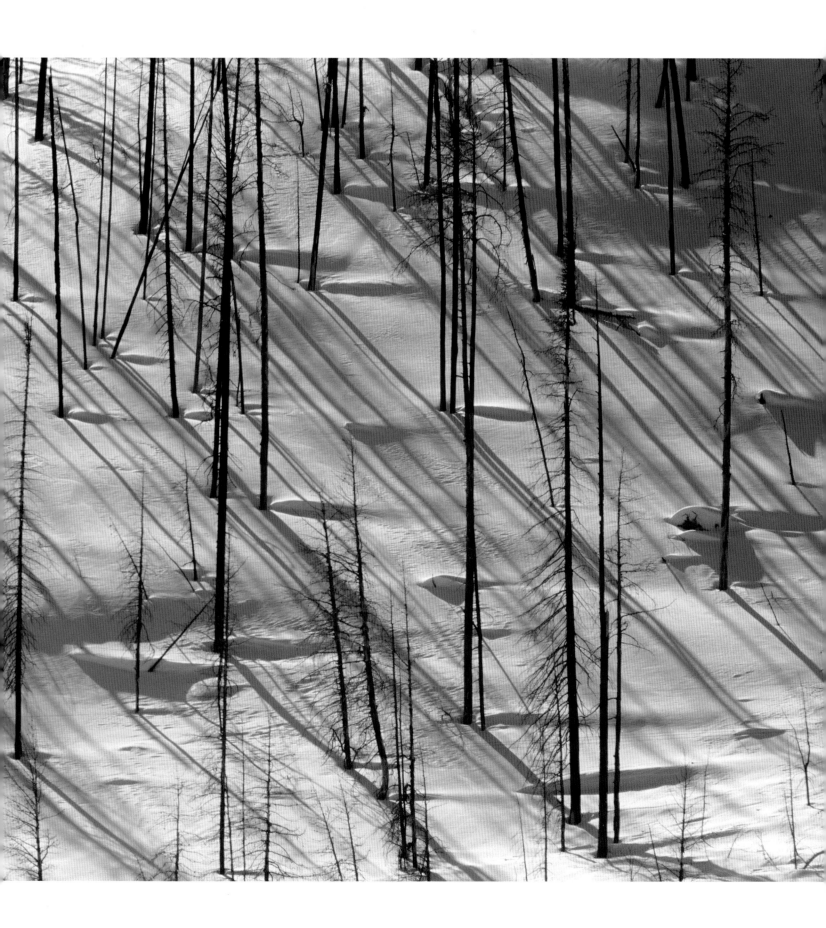

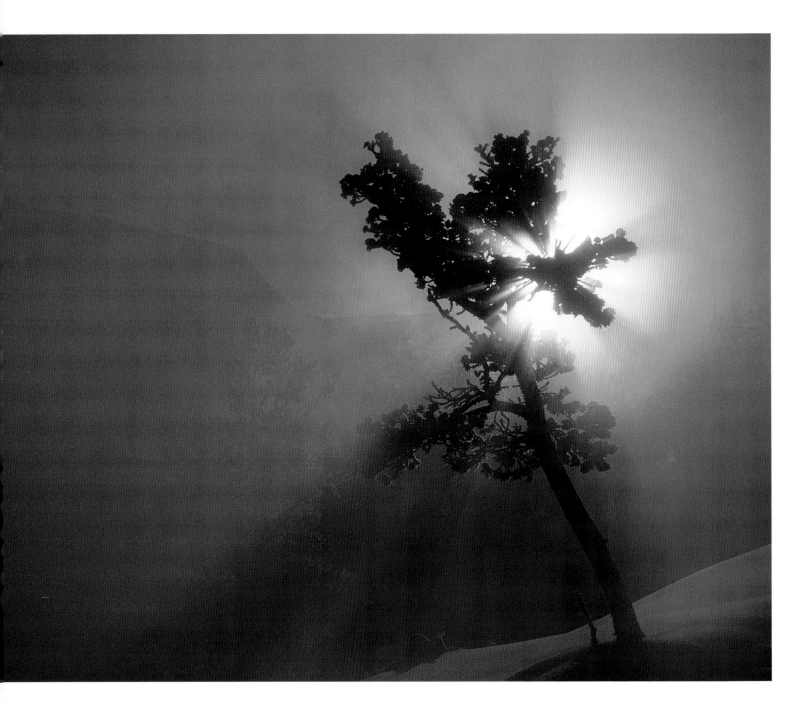

The brief, gold light that occasionally appears at sunrise shines through fog from Minerva Terrace. In the two minutes or so that this light stayed, I watched the gold rays fan out from the obscured sun as the fog drifted around the tree.

From the little footbridge over the Firehole River I could see columns of steam rising in dozens of spots. The extreme cold made every thermal impressive. Even this little, virtually unnoticeable geyser called Sprinkler was competing as an attraction in the Upper Geyser Basin, home to more than half of the major geysers in the world.

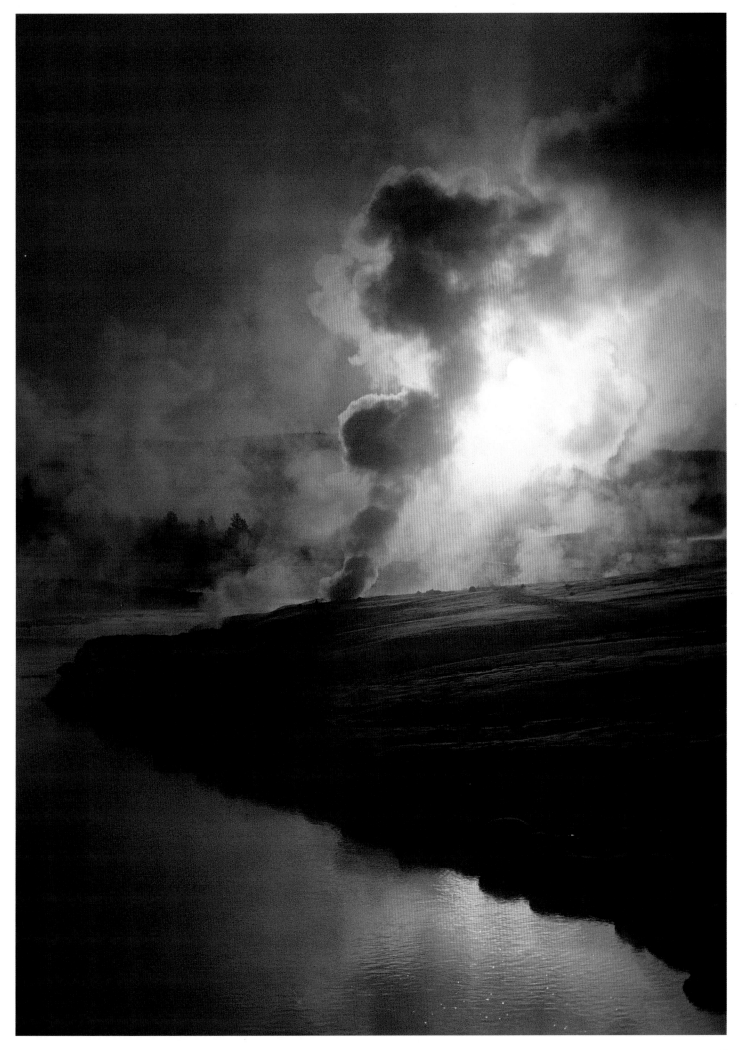

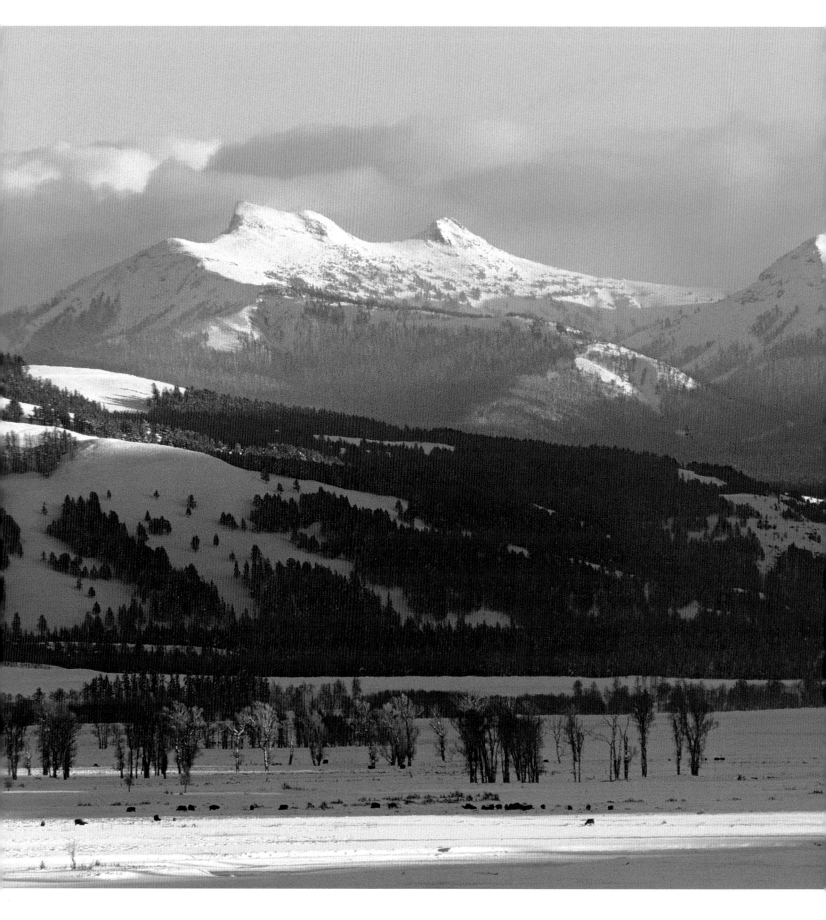

This photograph was made looking up the Lamar Valley to the east boundary of Yellowstone. Located between Miller Creek and the Upper Lamar, these two peaks—Saddle Mountain and Little Saddle Mountain—are landmarks for travelers in the remote backcountry.

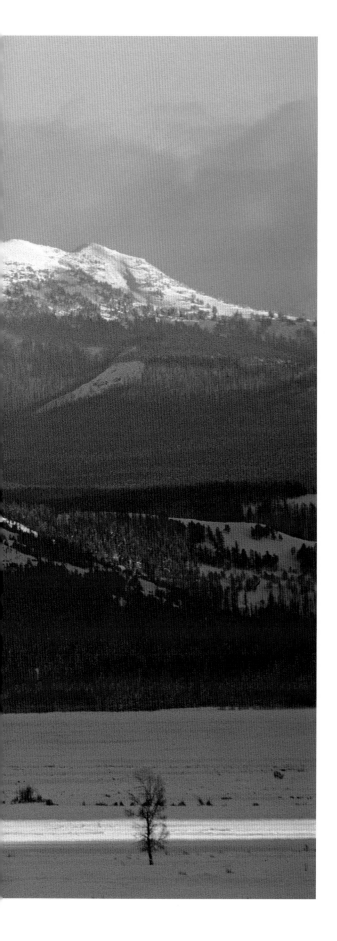

Native Americans gave the name "song dog" to the coyote. Lewis and Clark called them "prairie wolves." Their vocalizations include yips, barks, and howls. One coyote can sound like three or four. This individual howled for five seconds or so and then stood and listened. Another coyote answered him. He looked in that direction and howled again. The next time he listened, still another coyote responded from a different direction. He turned, looked, and answered back. He spun around, howling and barking, in six different directions for about ten minutes, trying to tell everyone in the neighborhood all he could.

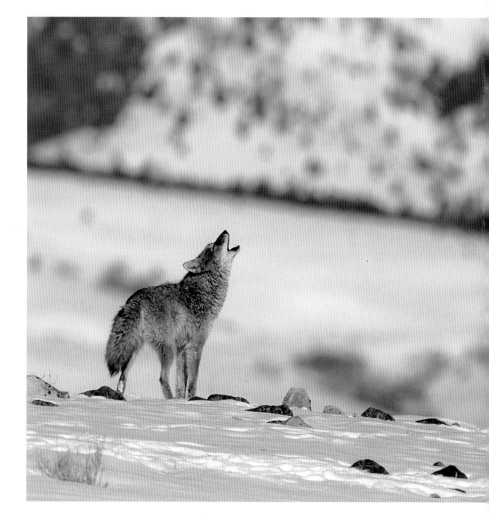

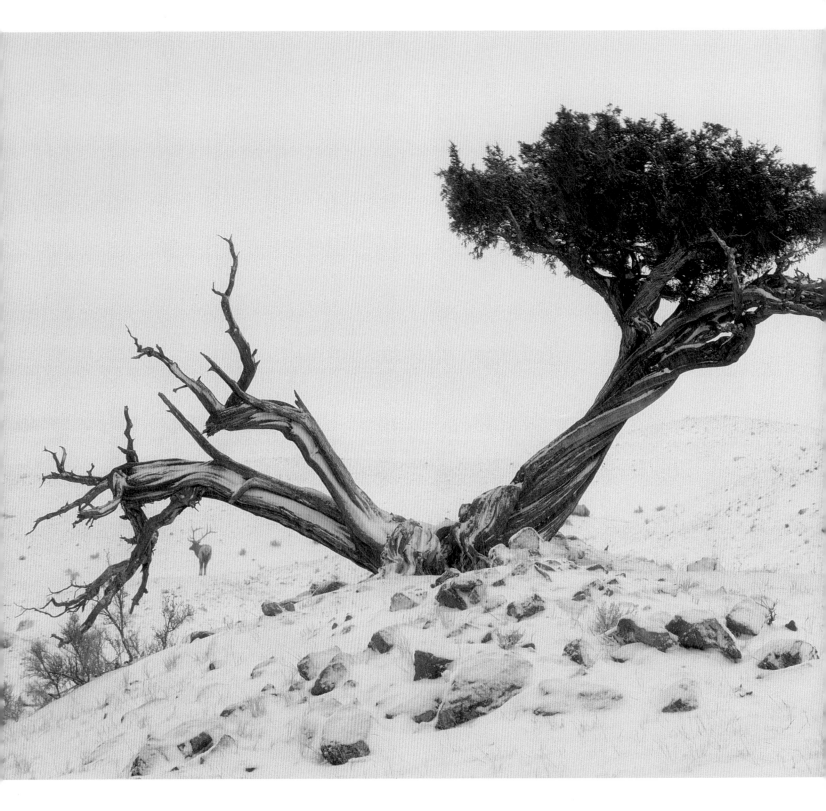

Juniper trees grow in arid environments and are uncommon in Yellowstone. They grow very slowly and this one is probably several hundred years old. It and the bull elk were at a low elevation in the dry rain shadow of Electric Peak.

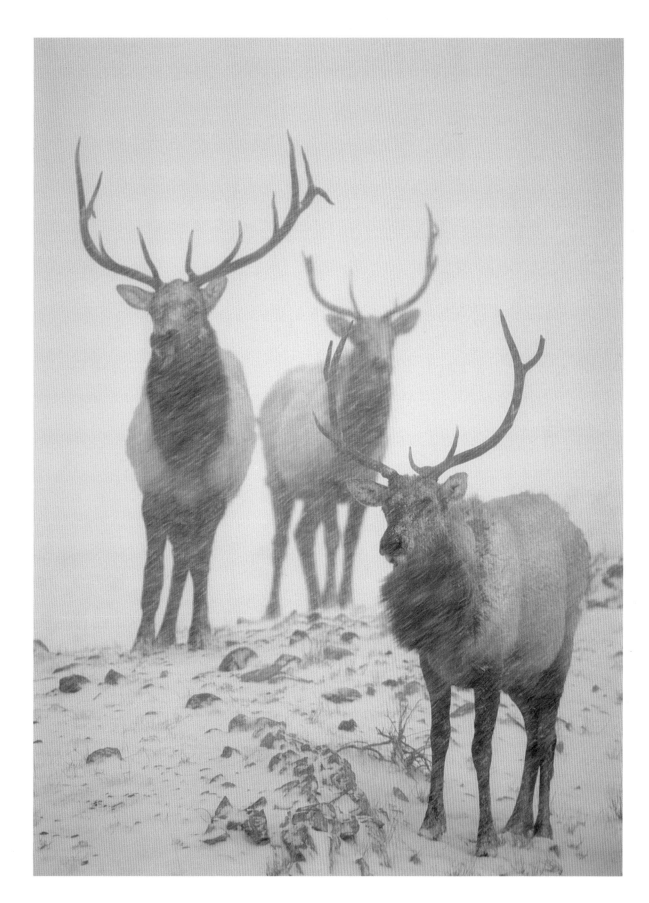

Except during the mating season in September, mature bull elk stay in small bachelor herds. These three bulls were part of a bachelor herd of about twenty-five bulls. Most of them spent the entire winter together, scattering into smaller groups in the summer, and then furiously fighting with each other in the fall.

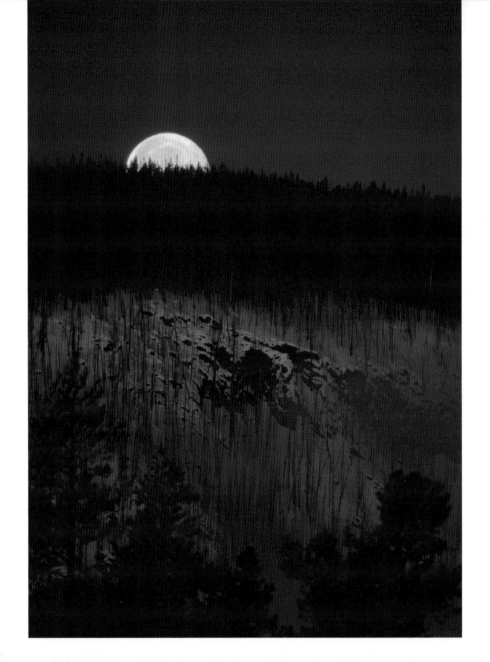

Twenty minutes before sunrise on the day after a full moon, I watched the moon setting over the ridge west of Black Sand Basin. A moonset is as captivating and grand as a moonrise, but for some reason I rarely wait for it to set but always stop to watch it rise.

To make star-track photographs one needs a clear sky, no light pollution from artificial sources, and no moon. Most of Yellowstone is perfect for this. The ridge in the foreground is Mount Everts. The exposure was for about three hours with the lens facing to the southeast. Notice how colorful our stars are and how we are spinning through space. I am reminded that we are on a tiny blue and white planet floating through an unimaginably vast, black void studded with these stars.

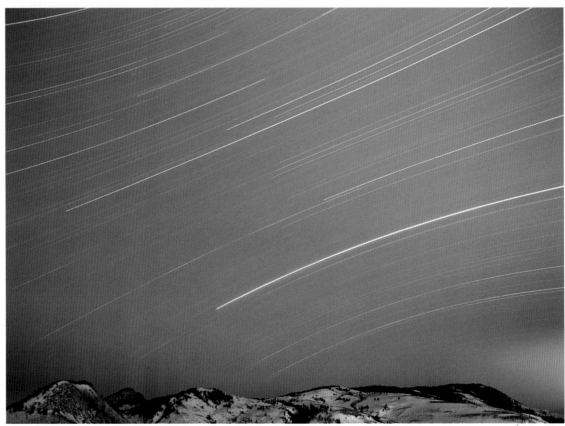

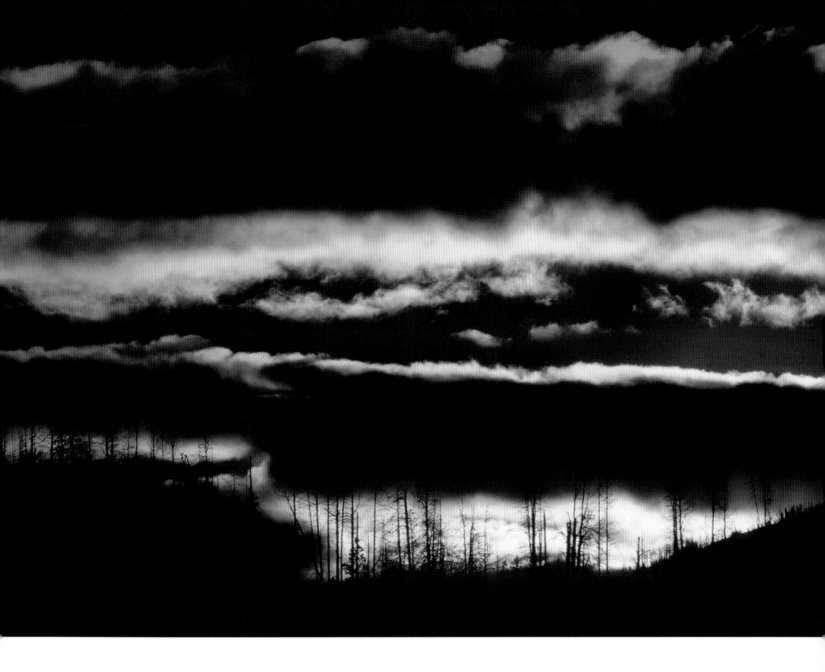

On Swan Lake Flat there is a good view to the east over Blacktail
Plateau. The foreground contains trees burned by the North Fork
Fire of 1988. Typical winter clouds were visible here, stretched
smooth and backlit for a minute or so by the rising sun.

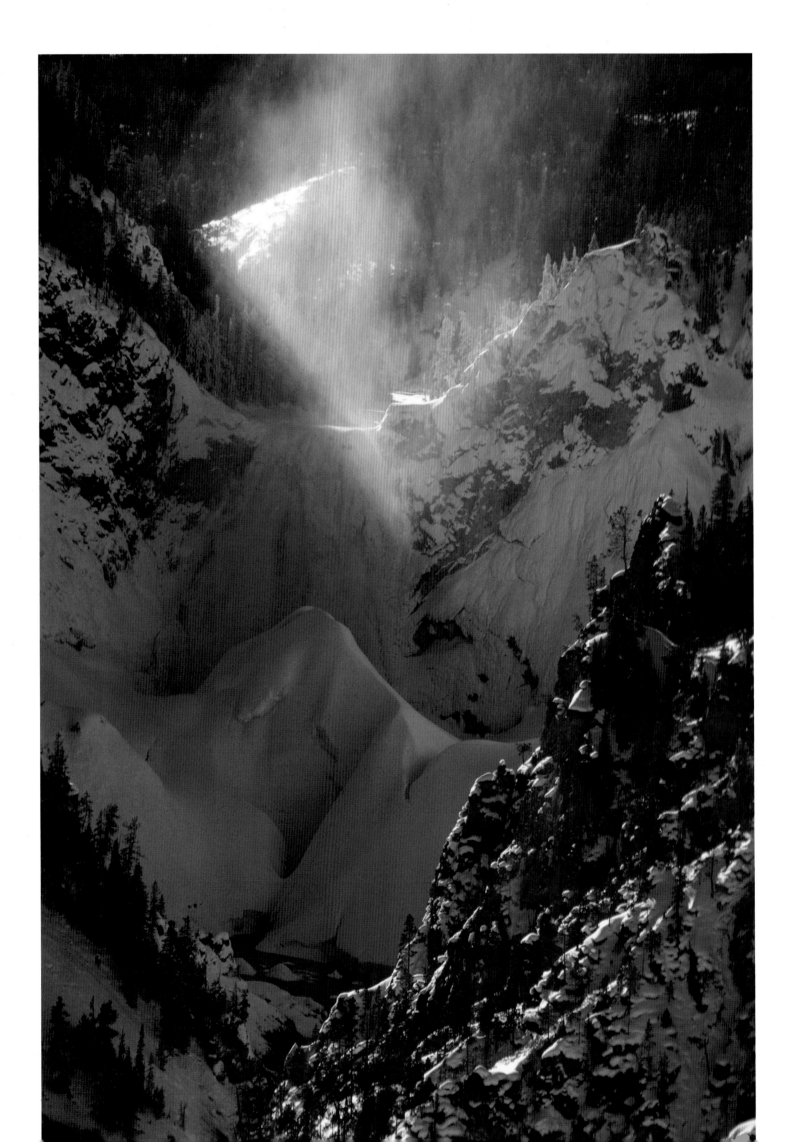

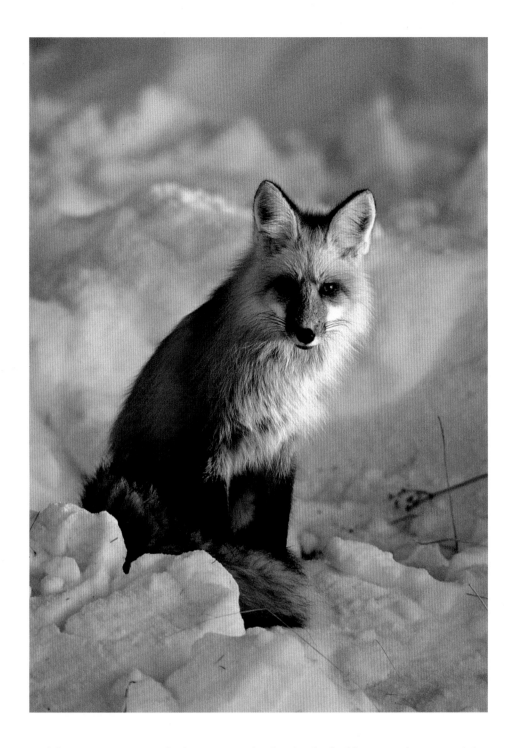

Red fox are opportunistic feeders. During the day this fox had been traveling around the Lamar Valley hunting rodents and looking for anything to eat. He curled up and took a nap in the late afternoon. I waited for him to do something more interesting, and just at sunset, he sat up, looked around, stretched, and walked away as the sun went down.

The Lower Falls of the Yellowstone is 309 feet high. At the bottom of the falls the river hits a layer of rock and ricochets out, producing clouds of mist. This mist freezes into a giant cone of ice, its size dependent on the intensity and duration of the winter. The cone usually reaches a height of 150 feet, but during a long, cold winter it can approach 200 feet, about as tall as a twenty-story building.

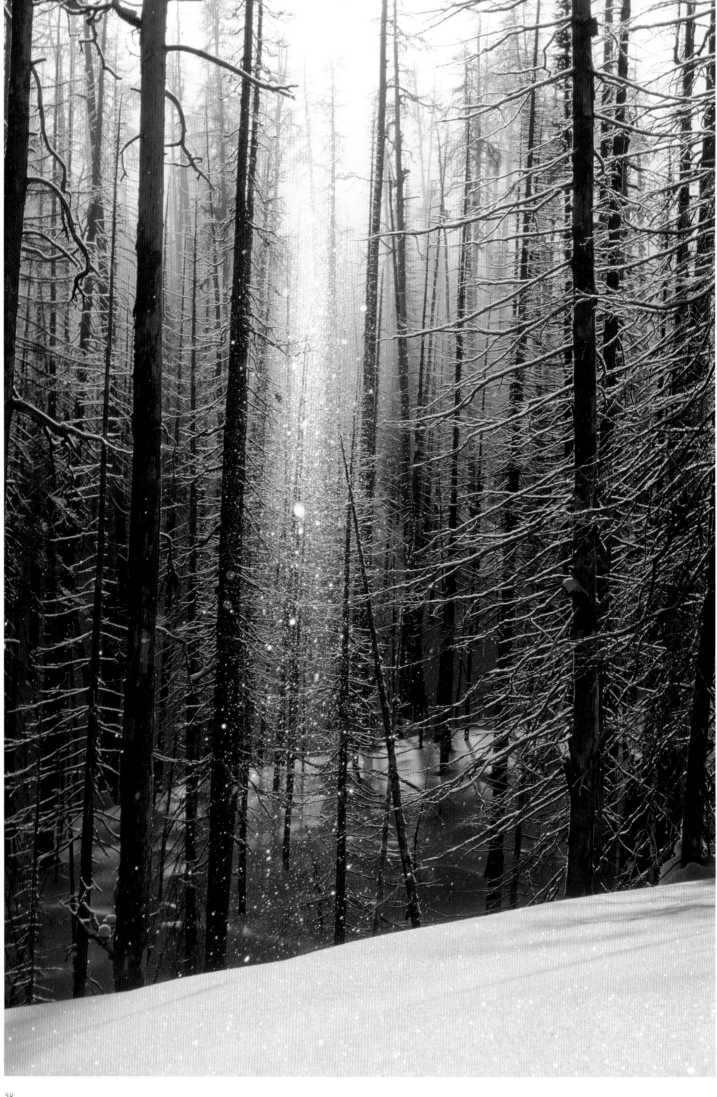

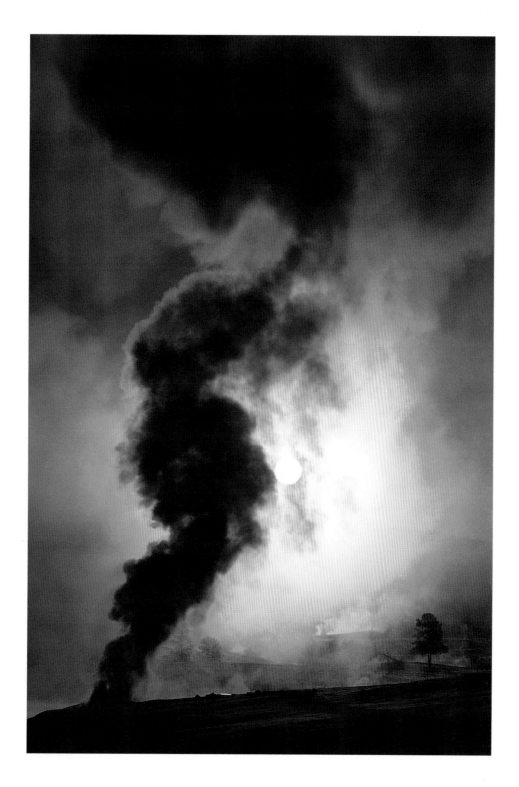

Winter is the best time to observe Yellowstone's thermal features because they are so much more dramatic and visible than during the summer. The interaction between boiling water and subzero air creates an entirely unique world of clouds, fogs, frosts, ice, and winds. This small thermal feature produces an impressive column of steam in the Upper Geyser Basin.

Some mornings—if conditions are just right—tiny, needle-point ice crystals called diamond dust appear in the air. Diamond dust forms out of atmospheric humidity when it is very calm and very cold—usually below zero. The crystals are so small they float in the air and twinkle all around you. If they are backlit by the sun against a dark background, they appear like a column of sparkling diamonds.

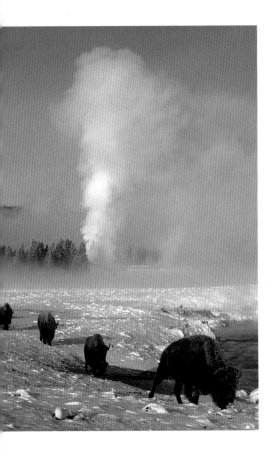

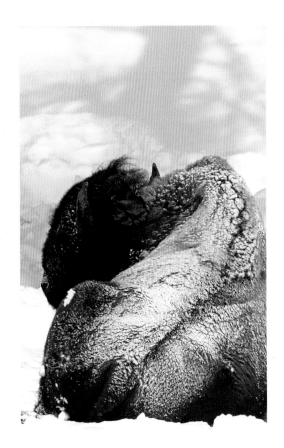

Bison that have committed themselves to wintering in the Upper Geyser Basin follow a daily pattern of movement. At night they sleep on patches of ground that are geothermally heated; during the day they move about to feed on whatever meager forage they can find. Castle Geyser is erupting in the background as this small bunch travels towards a feeding area.

Bison bulls have massive, powerful heads and shoulders and, by comparison, almost dainty rear quarters. The shoulder hump is formed of muscle on a set of bone spines or processes extending up from the vertebra. On a big bull these heavy spines can be eighteen-inches long. The curve from a bison's neck to his tail is dramatic and graceful even when he is lying down.

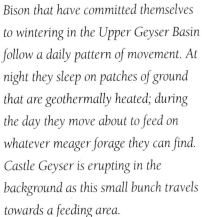

Heart Spring on Geyser Hill is named because it is shaped like a human heart, not the valentine variety. With little runoff and a very hot, deep pool, it gently simmers and steams almost unnoticed. A lacy sinter rim defines the edge of the hottest part, and the snow defines the edge of the entire feature.

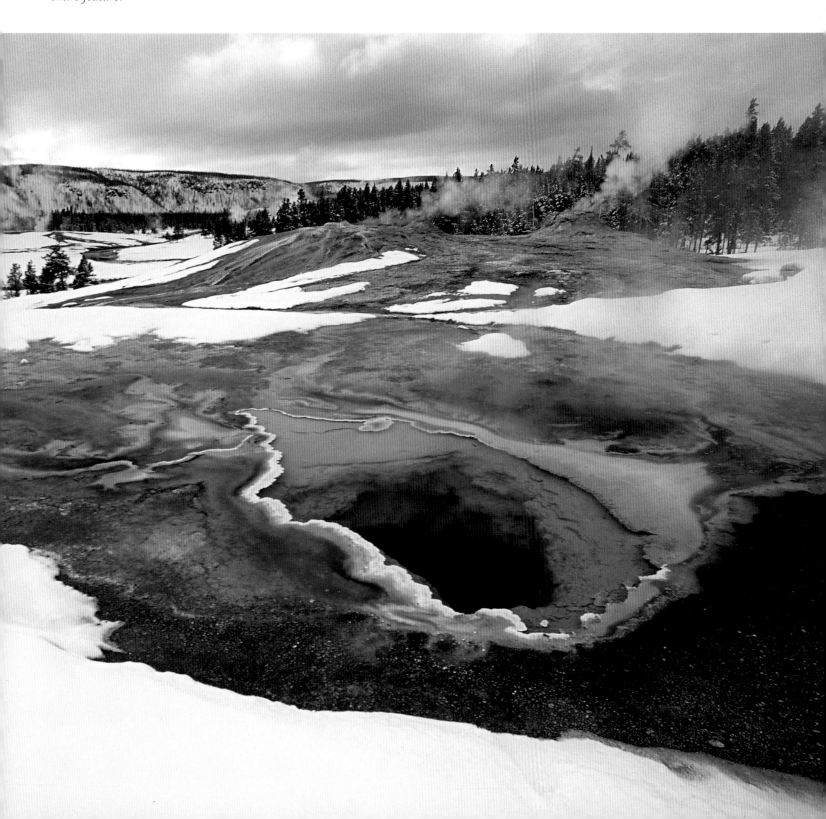

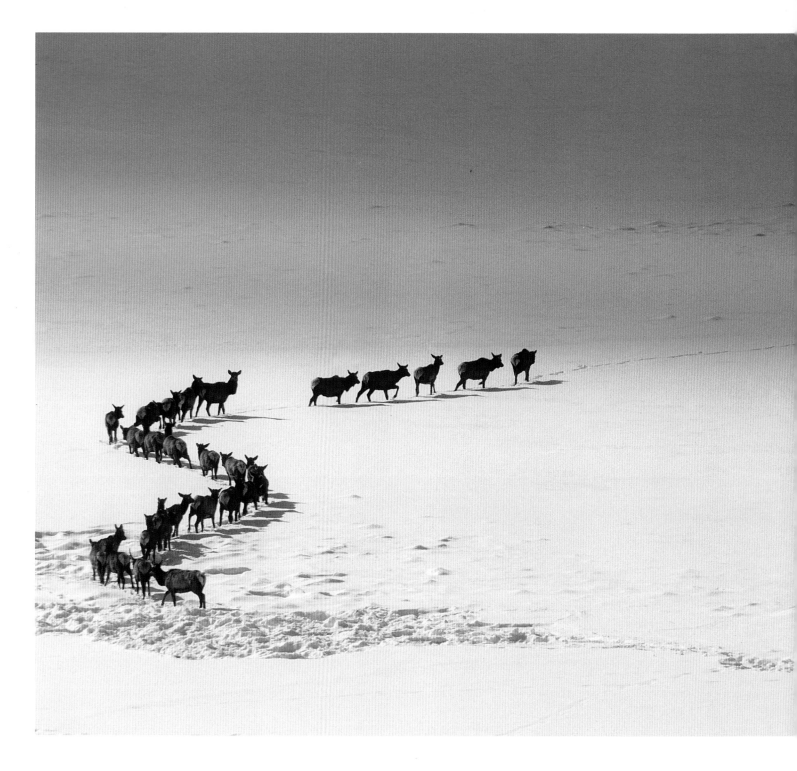

In the winter, mice usually live in a snow-covered world of tunnels and pathways along the surface of the ground where it is relatively warm—around freezing. When elk and bison feed, they push or paw away the snow to expose grass and other food, and they inadvertently expose the mice pathways to predators. This coyote was checking the disturbed snow for mice as the elk moved away.

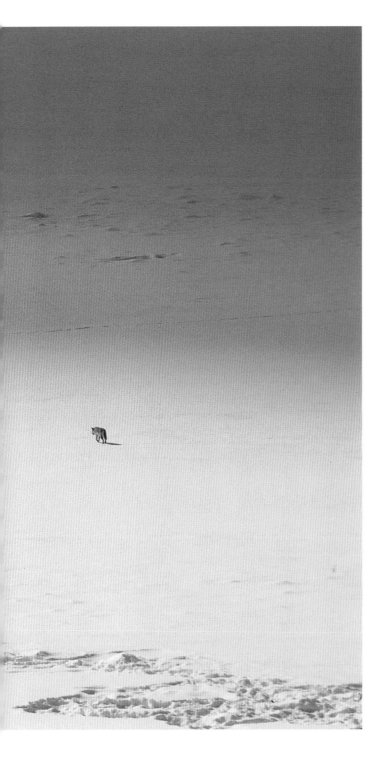

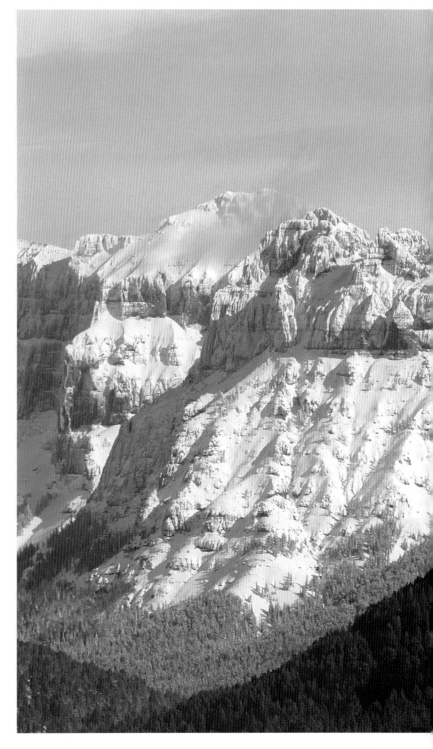

Amphitheater Mountain in the Absaroka Mountains presents a steep, high face that looks down onto Soda Butte Creek in the northeast corner of Yellowstone. These volcanic sediments and lava flows from the Eocene 40-50 million years ago are loose and fractured, making climbing extremely dangerous. Few people travel to this remote area.

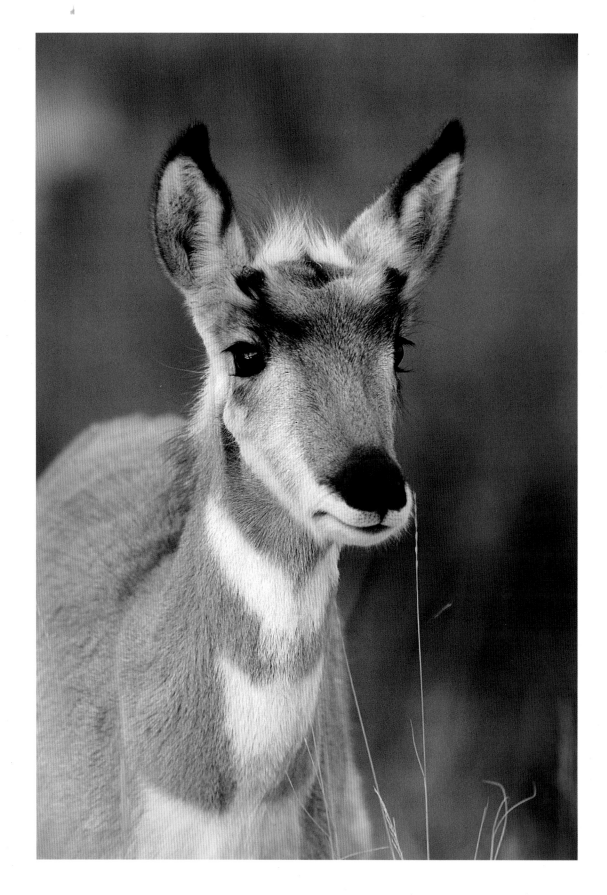

At seven months old this pronghorn antelope (above) is completely independent of her mother, but like most other ungulates, she will stay with a herd for her entire life. The security of pronghorn depends on their ability to run very fast for long distances. Deep snow is deadly; not only does it cover up their food, but it prevents them from running away from predators. In the winter, Yellowstone's antelope inhabit the low, windswept benches near Gardiner (right).

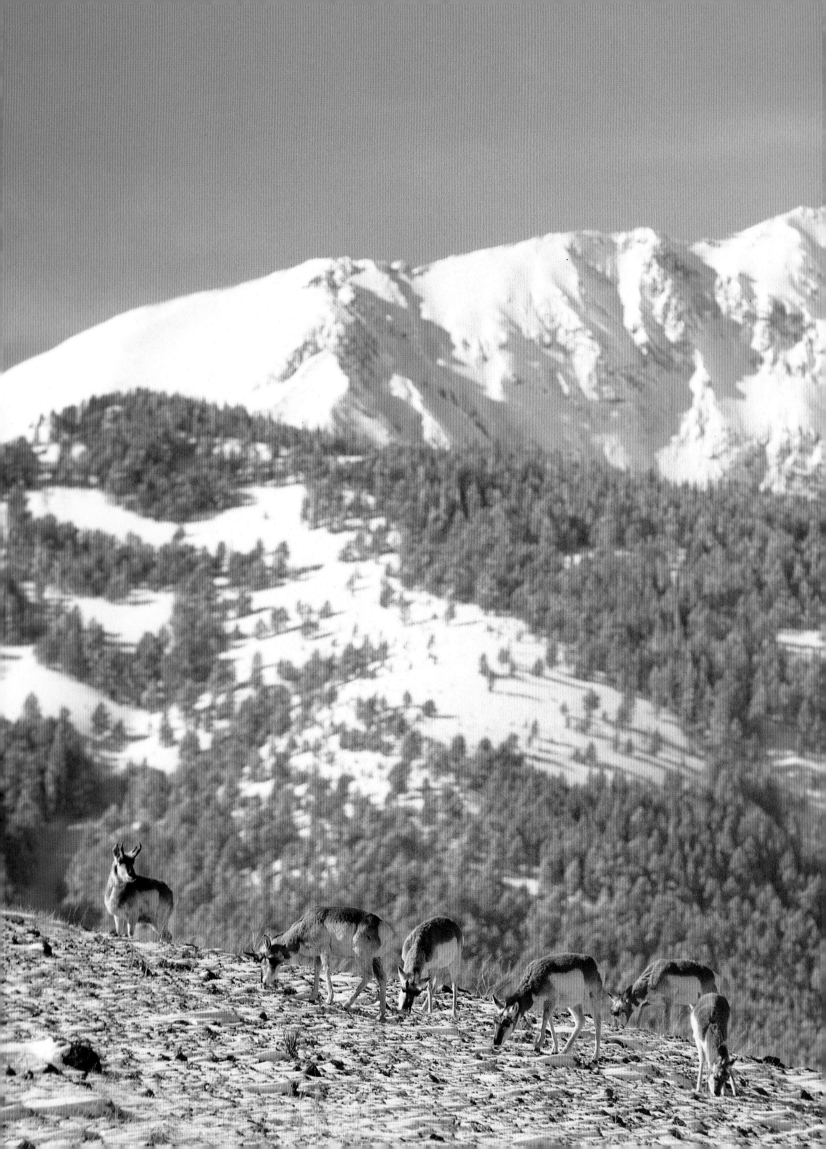

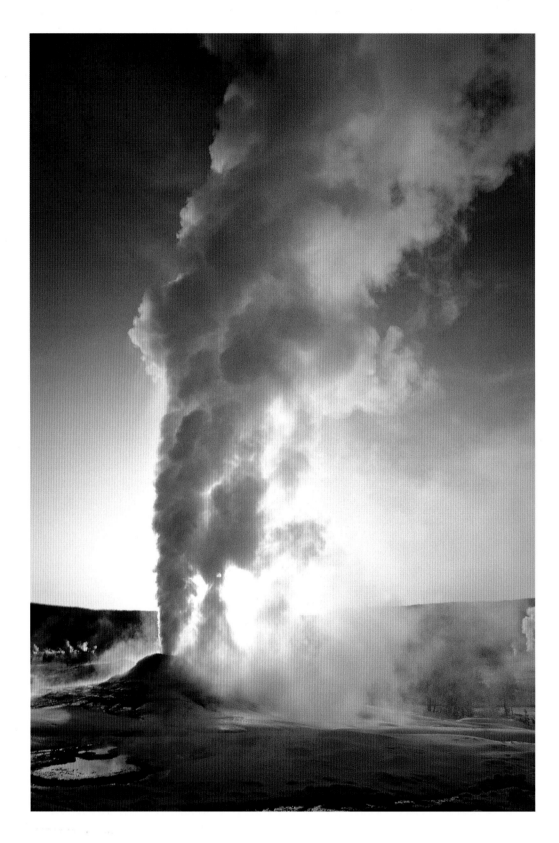

The Lion Group consists of four geysers: Lion, Lioness, Cub, and Little Cub. The name "lion" comes from the deep roar produced during an eruption by this largest geyser of the bunch. The low rumbling song of Lion Geyser is like the earth happily humming to itself while out for a stroll.

Wildlife must learn how to negotiate the special hazards of geyser basins. Boiling hot springs and erupting geysers seem pretty obvious, but animals do get burned here. This cow and calf elk were climbing the south side of Geyser Hill after crossing the Firehole River. They had to pick their way across the thin crusts of sinter past Beehive, Plume, and Giantess geysers. There are always animal tracks in the algae and bacteria mats of the thermals. Occasionally you see tracks breaking through the rock crusts, and sometimes you find bones in the hot springs.

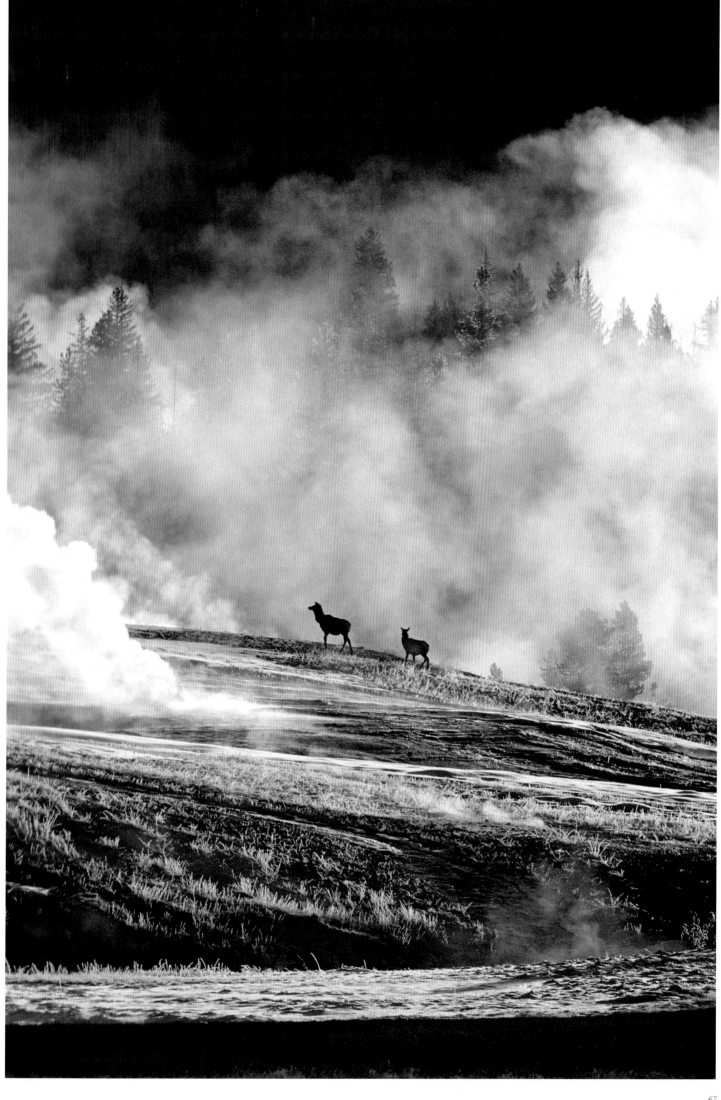

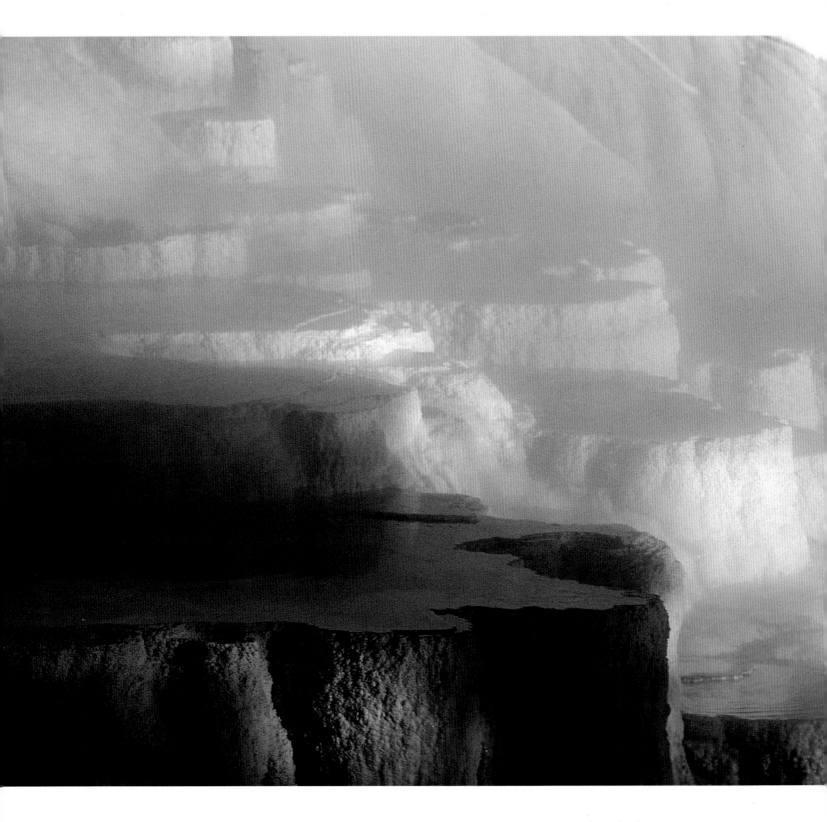

Canary Spring's name comes from the formation's canary-yellow color. Water flowing down the rocks supports algae and bacteria of all colors but predominantly yellow. Pools are rimmed by travertine rock that forms where the water cools. National Park Service geologists estimate the Mammoth Hot Springs formation, where Canary Springs is located, produces two tons of rock a day.

A small elk herd lives around Mammoth Hot Springs, the headquarters of Yellowstone. The elk seem to like the lawn grass as part of their summer diet and the warm ground for their winter beds. The base of Canary Spring is visible beyond the cow elk. The cow is walking away from an old reservoir that now holds the runoff from Canary but used to supply water for a power plant that generated electricity for the Mammoth area one hundred years ago.

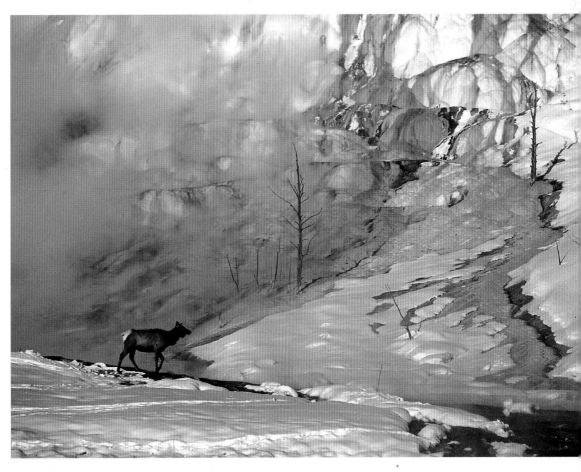

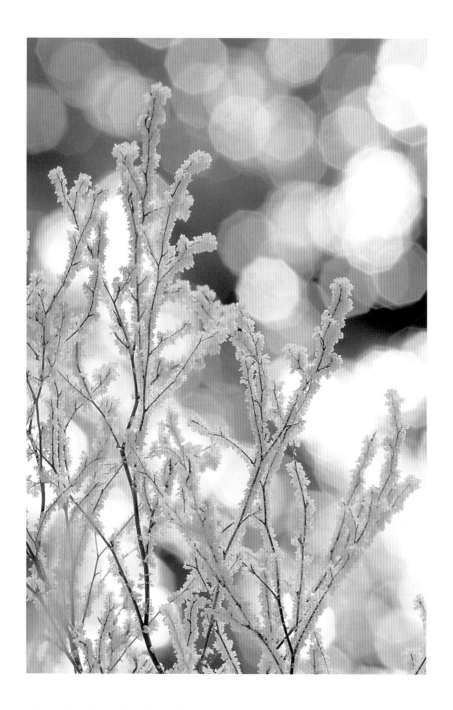

Heavy frost formed on these dry sweet clover stems during an early morning fog in the Upper Lamar Valley. The soft circular shapes in the background are sparkles on the surface of the Lamar River.

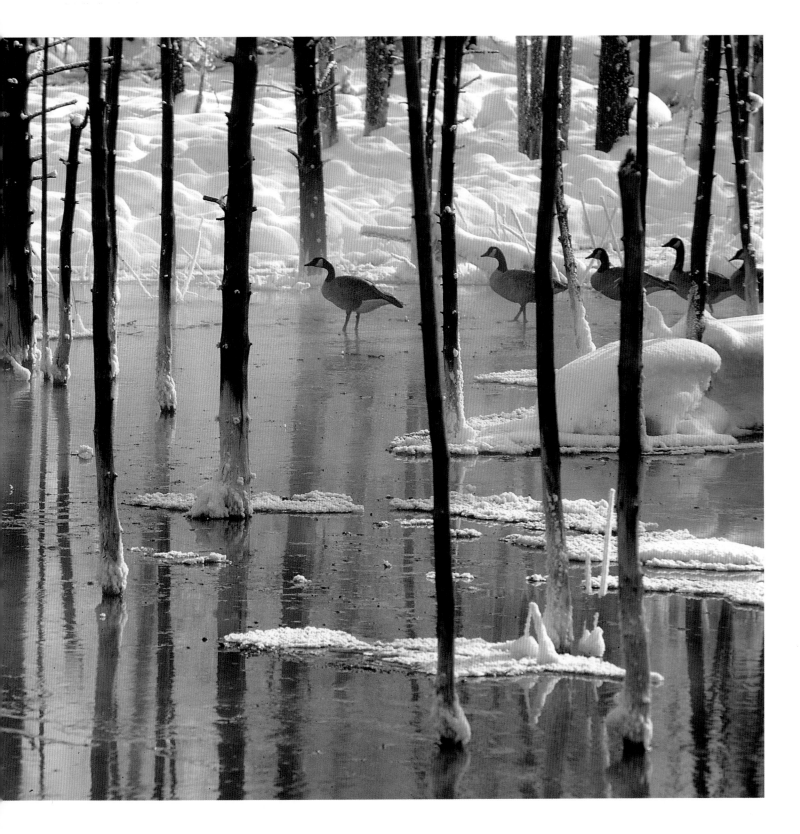

Runoff from the geysers and hot springs in the Lower Geyser Basin has flooded acres of pine trees. These shallow pools never freeze, so aquatic plants are available year-round. This food attracts wildlife. The five Canada geese were wading through a steamy maze of dead trees, seemingly murmuring winter gossip or weather reports.

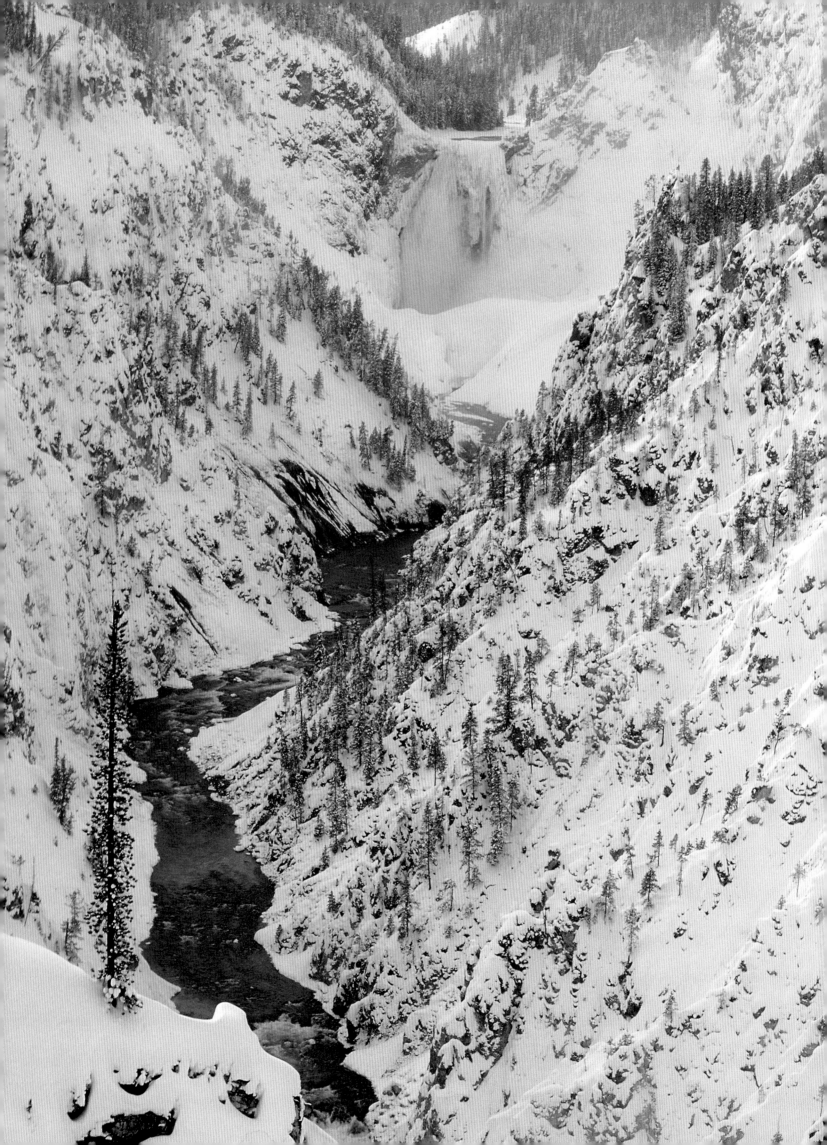

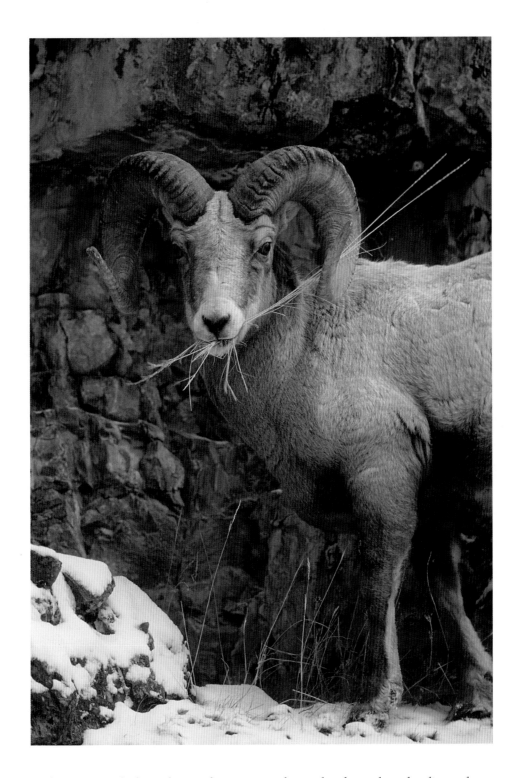

Rocky Mountain bighorn sheep—their name explains a lot about where they live and about their most distinctive feature. A year for them is to live at high elevations in the summer, usually above timberline, and at lower elevations in the winter where there will be more grass available. They always live on or near a steep rocky place for security.

This view of the Lower Falls of the Yellowstone from Artist Point is one of the classic images of the American West. Never mind that the artist it was named for, Thomas Moran, never painted a view from here, or probably never even stood here. This section of the Yellowstone River would qualify as a national park all by itself. Millions of people have stood here, some of them in awestruck silence, absorbing the low whisper of the falling water a mile away, the clean smells, the cool breeze, the colors and textures of the canyon walls, the precarious lives of the trees, the overwhelming sense of vastness, and with gratitude for the foresight and the luck we have had that this place is still wild and protected.

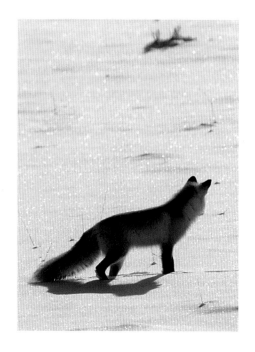 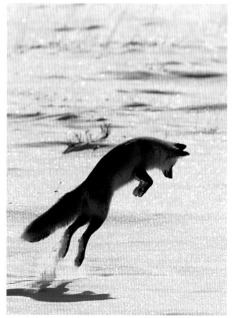 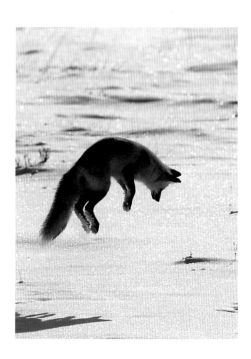

I watched this red fox all afternoon one January day as he wandered along listening for mice and voles under the snow. He could probably smell the rodents just fine, but their scents, drifting up through the snow, gave no precise clues for locating them. He locates them by sound.

Mice and voles have nests and tunnels underground, but they go out in the snow-buried grass to get food. When they tunnel in the snow, they make plenty of noise for a fox to hear, even through two feet of fluffy snow. Of course, the rodents can hear things moving on top of the snow too, so when something crunches above them they run for their burrows or huddle quietly.

Moving slowly, this fox caught the sound of a small rodent under the snow. He very carefully stepped closer, obviously trying to be quiet. Tipping his head from side to side seemed to help pinpoint the sound. The fox occasionally held his breath with an intense, wide-eyed look indicating the seriousness of the hunt, but it still made me smile to watch him.

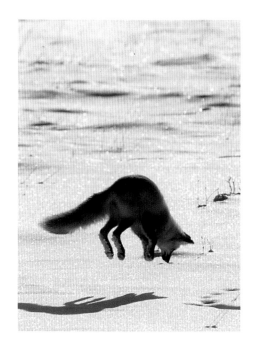 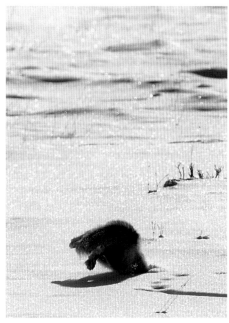

His prey was out of sight under the snow so he had to plan a trajectory through an unknown space. There were rocks, bushes, and sticks that he could strike on the way to the ground. He bunched up his feet to power his jump with his hind legs, listened again for any scratching, rustling or nibbling sounds, and launched himself into the air.

A red fox is not very heavy, so in order to punch down deeply into the snow, he had to jump as high as he could. This sequence was shot at six frames per second so it lasted one second. Nearly disappearing into the snow, the fox pushed his front paws ahead of his nose to try to pin the rodent to the ground. He held still as the snow tumbled around his buried head.

After three or four seconds he realized he had missed, and he backed out of the hole in the snow. Blinking and shaking the snow out of his eyes and ears, he stood up, shook his entire body, licked the moisture off his lips, and walked on to try again. Meanwhile, I am sure the mouse was recovering from a little heart attack and deciding when it would have nerve enough to go out again.

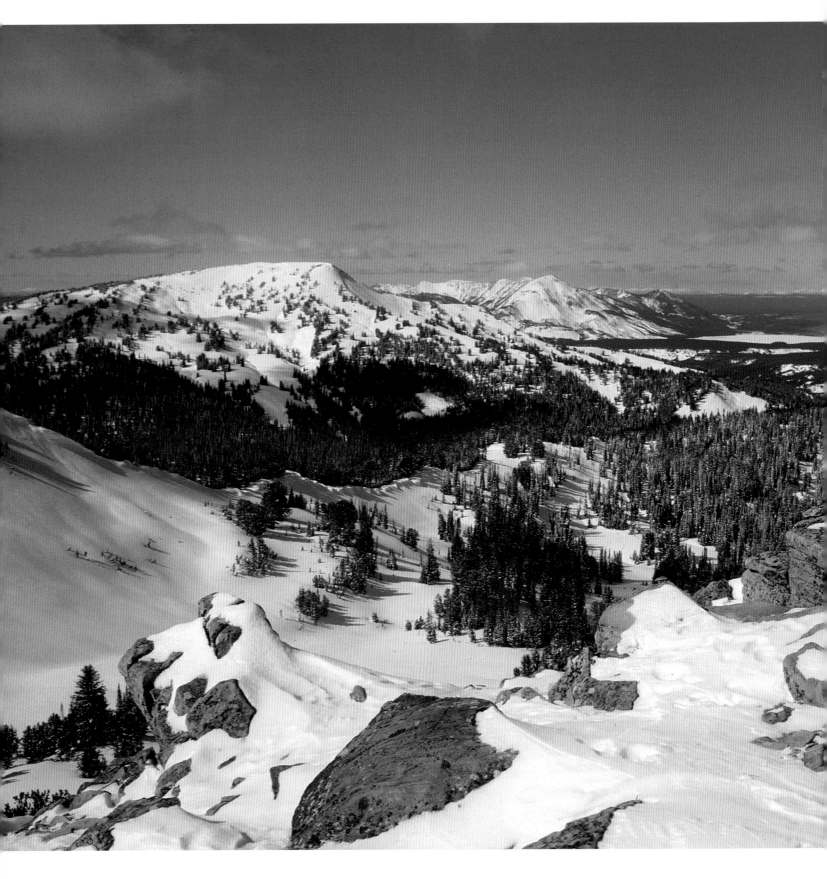

In February and March 1985 I cross-country skied solo across Yellowstone. My 125-mile route took me up and over Big Game Ridge on the south boundary of the park. The main reason I climbed the ridge was for the view. Looking south I could see the Tetons and looking north, shown here, I could see the Red Mountains and Heart Lake area. This was the fifth day of my fourteen-day trip and one of the two days that it didn't storm.

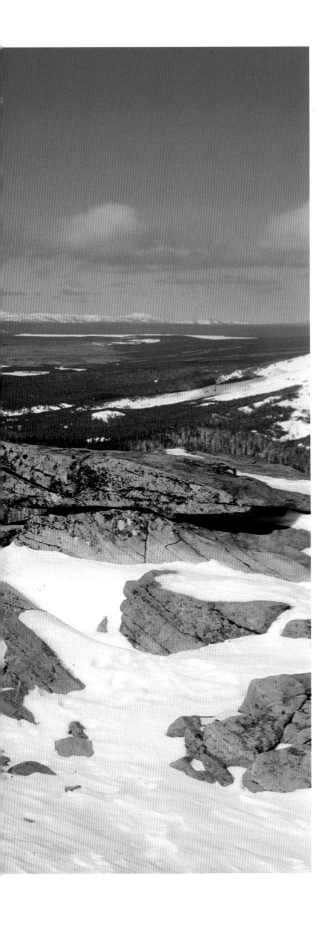

Grizzly bears hibernate during the winter so it is unusual to see them walking around on the snow. This young bear was out in late winter looking for winter kills, an important food source for emerging grizzlies.

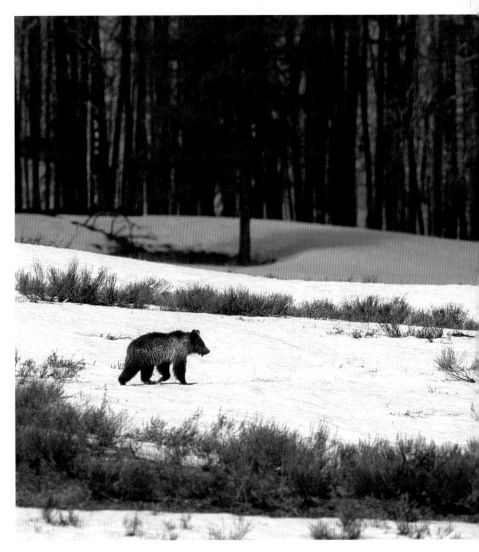

Traveling across the floor of Lamar Valley, this coyote was looking for food and not having much luck. Running across an elk skeleton from the previous spring, she investigated the scattered leg bones and ribs. The skull interested her the most. She rolled it around with her front feet and chewed and licked it for a couple of minutes, then gave up on the whole thing and went off to find something fresher.

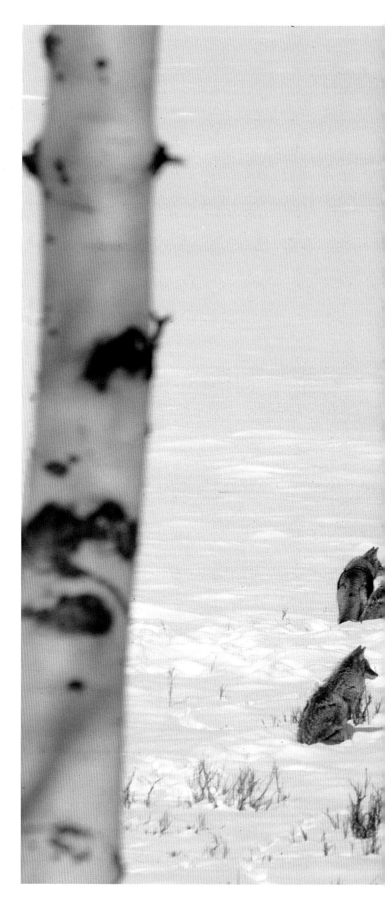

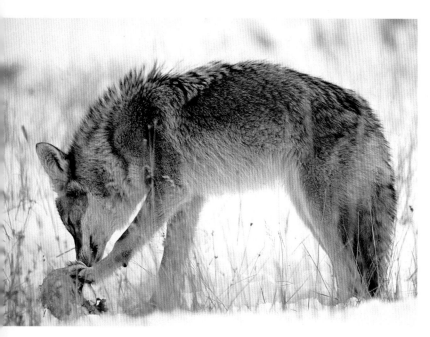

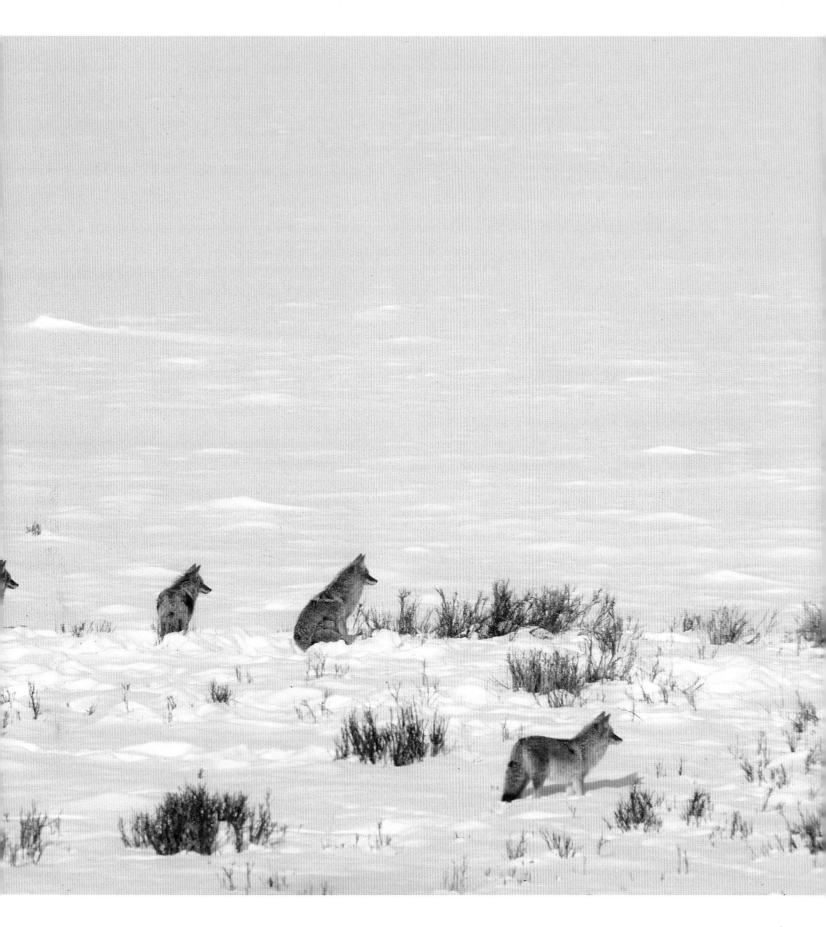

Although you will generally not see more than two adult coyotes together, several adults will hunt cooperatively at times. They are intelligent, social animals, so they are very adaptable. The six adults here were traveling up Slough Creek and stopped to listen to another coyote howling off to the north.

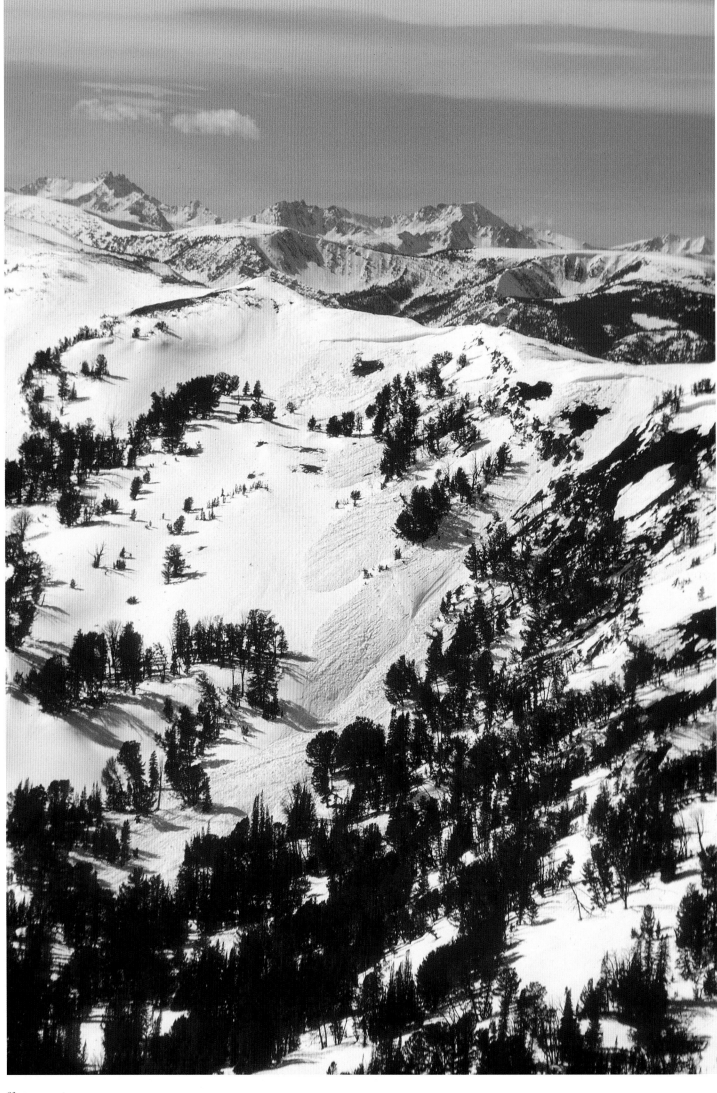

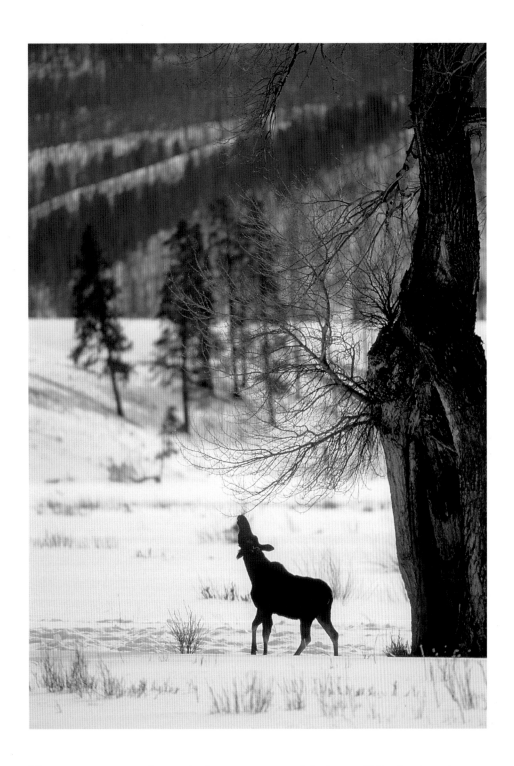

Moose are not commonly seen in the open expanse of the Lamar Valley in wintertime. This cow was traveling east toward Soda Butte heading for her normal winter habitat: heavy timber, where she would browse on spruce and willow buds. When she approached this large, old cottonwood tree, she stopped and stretched her neck high to nibble on the few small branches that the elk had missed.

On a three-day trip in April two of us had skied up the southeast ridge of Electric Peak from Gardners Hole. The day before had been sunny and warm. Most of the open 30-50 degree slopes had slid that day in big, heavy, slab avalanches. By staying on the wind-blown edge of the ridge, we avoided the risk of starting more avalanches. This view is of the southwest ridge of Electric Peak and the Madison Range in the distance.

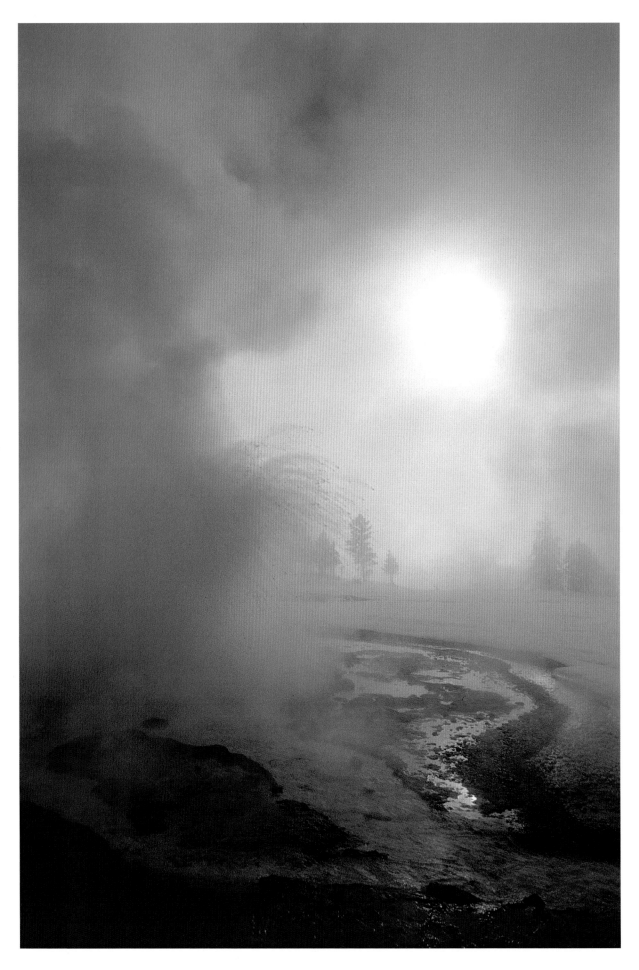

Sawmill Geyser is a fountain geyser, which means it erupts out of a pool of water. It burbles, pops, thumps, and splashes as bursts of hot water are forced up through the ten-foot-wide pool. These pulses of water have a tendency to spin, flinging out the water in a spiral as it goes up like sawdust spinning off a circular saw in a sawmill.

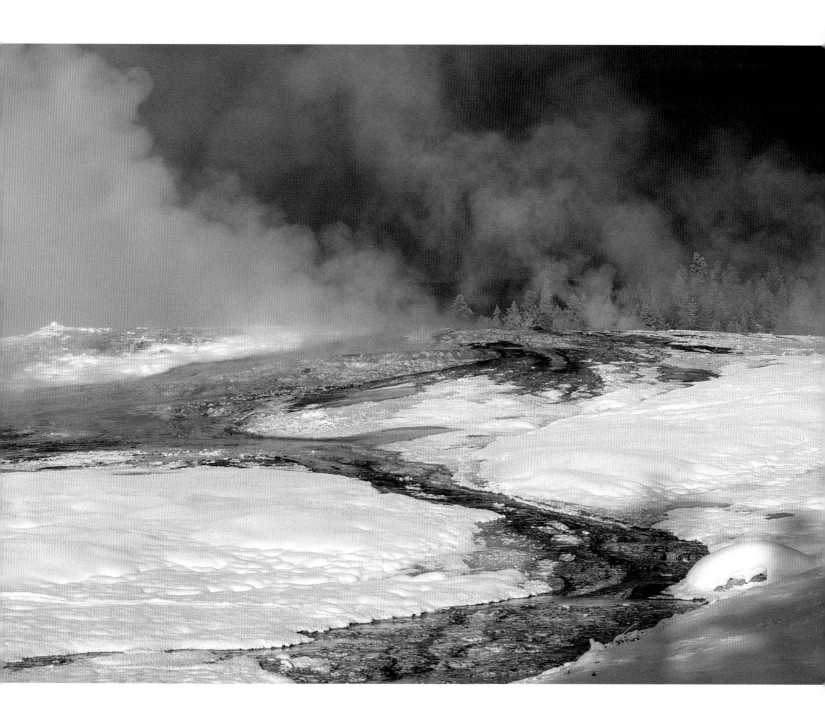

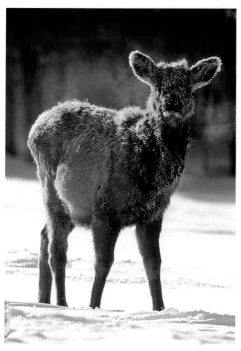

The Langford-Washburn party named Giantess Geyser in 1870. They observed it erupting in a solid column of water 150 to 200 feet high. Recently it has been active only several times a year. It still boils and overflows daily, producing delicate sinter terraces and colorful streaks of algae and bacteria.

This eight-month-old elk calf was walking slowly through the Upper Geyser Basin in the bright, cold sunlight. After walking through the steam, the tips of her hairs were coated with a fine, dense frost. She looked as if she had been gently rolled in powdered sugar.

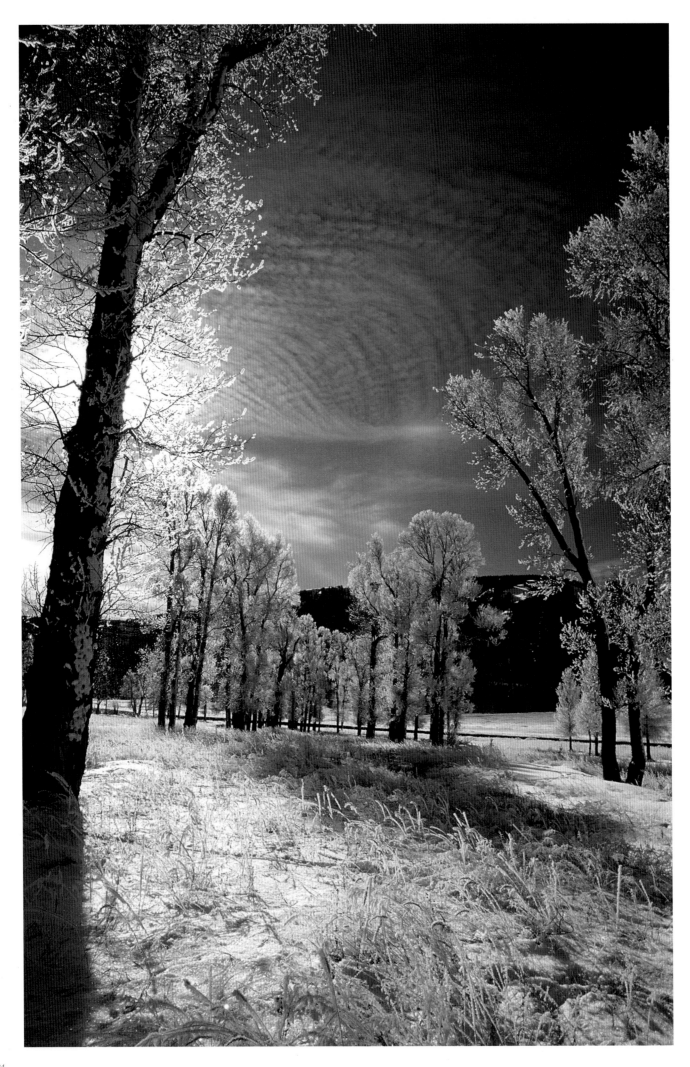

The Lamar River was slightly above freezing in late November. The early morning cold pulled moisture from the steaming river and carried it gently over the land, where it settled as frost on the colder vegetation. These cottonwood trees looked as if they had dressed themselves in elegant frosty feathers.

An early freeze the previous fall had killed this willow leaf before it could release from the stem. Drying into a tight curl, it held on in a brittle, determined way, surviving many storms. Its shape caught my attention. I liked the graceful curve contrasted with the cold, harsh frost and brittleness of the leaf itself.

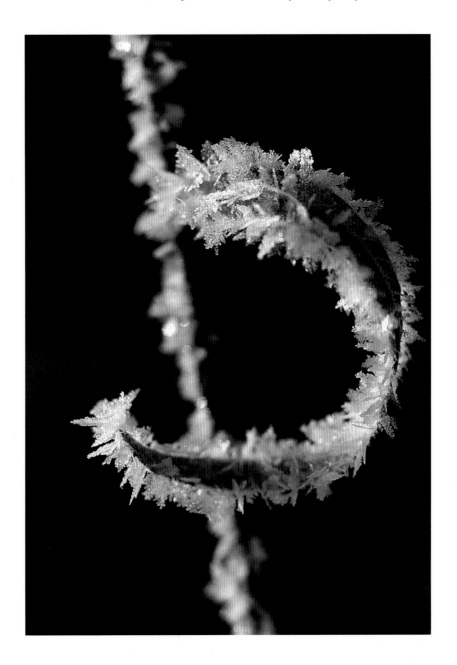

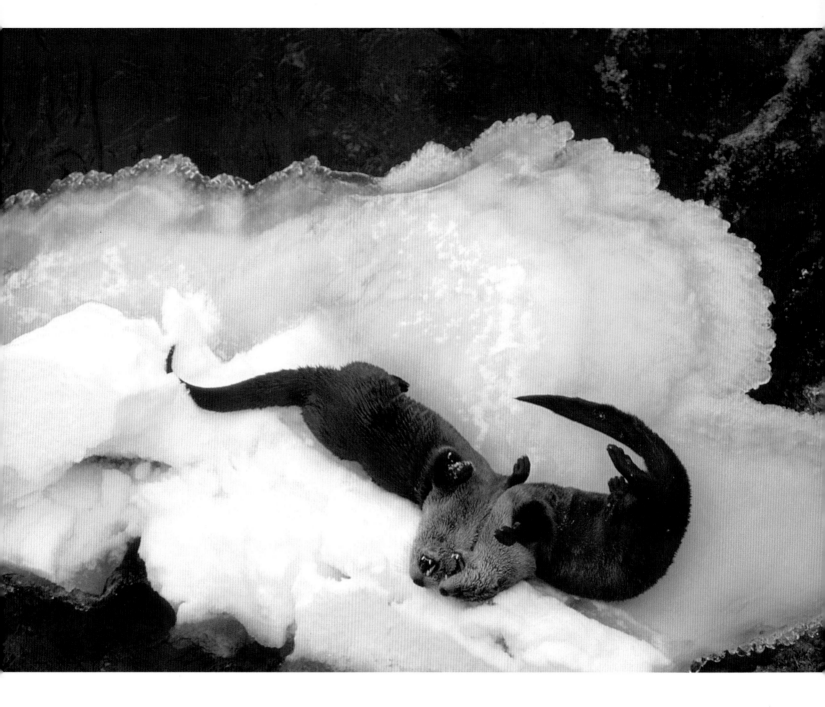

These two river otters were playing on an icy rock in the Yellowstone River. They were squirming and wrestling, completely unconcerned about the rushing white water all around them—or the 150-foot drop over the Upper Falls just downstream from them.

Tower Fall has a clear, vertical drop of 132 feet, which gives it the singular name. The wild, unrestrained leap also causes the water to smash hard on the rocks at the base, generating a wet, windy, microenvironment. During the winter the mist freezes to the canyon walls, and the ice often spreads completely over the fall, silencing it under a blue and white mask.

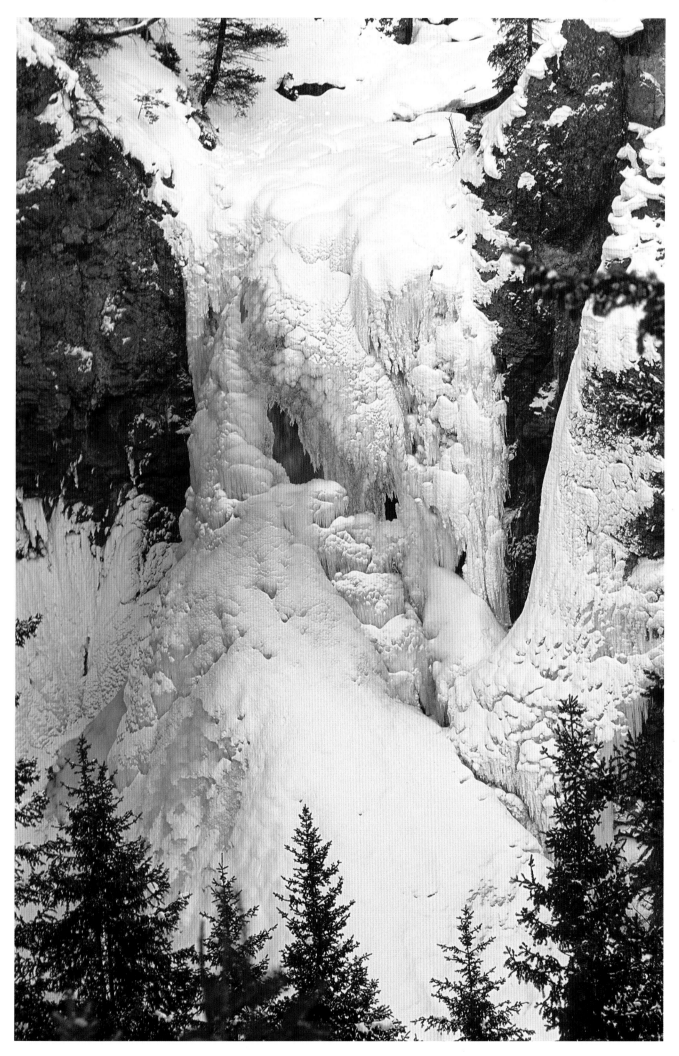

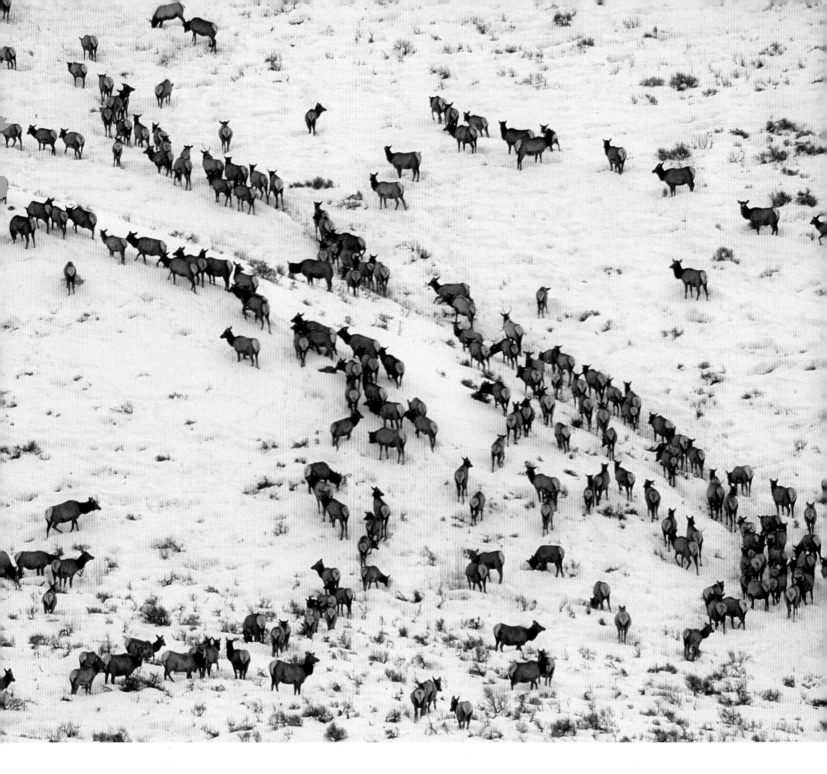

In the winter elk congregate at lower elevations where the snow is shallower and the weather milder. Herds of cows, calves, and young bulls are led by older cows in their daily search for food. When feeding, individuals scatter out and use their front feet to paw snow away from buried grass. If the older cows decide to move on, the rest of the elk slowly coalesce into small groups, then string out in lines converging to the lead animals' trails.

By late February it had become a long winter for this bull elk. His antlers were beaten up and broken. He was thin, and to find something to eat he was forced to put his nose in the thermally heated water and pull coarse reeds out of the mud. There were still two hard months ahead of him.

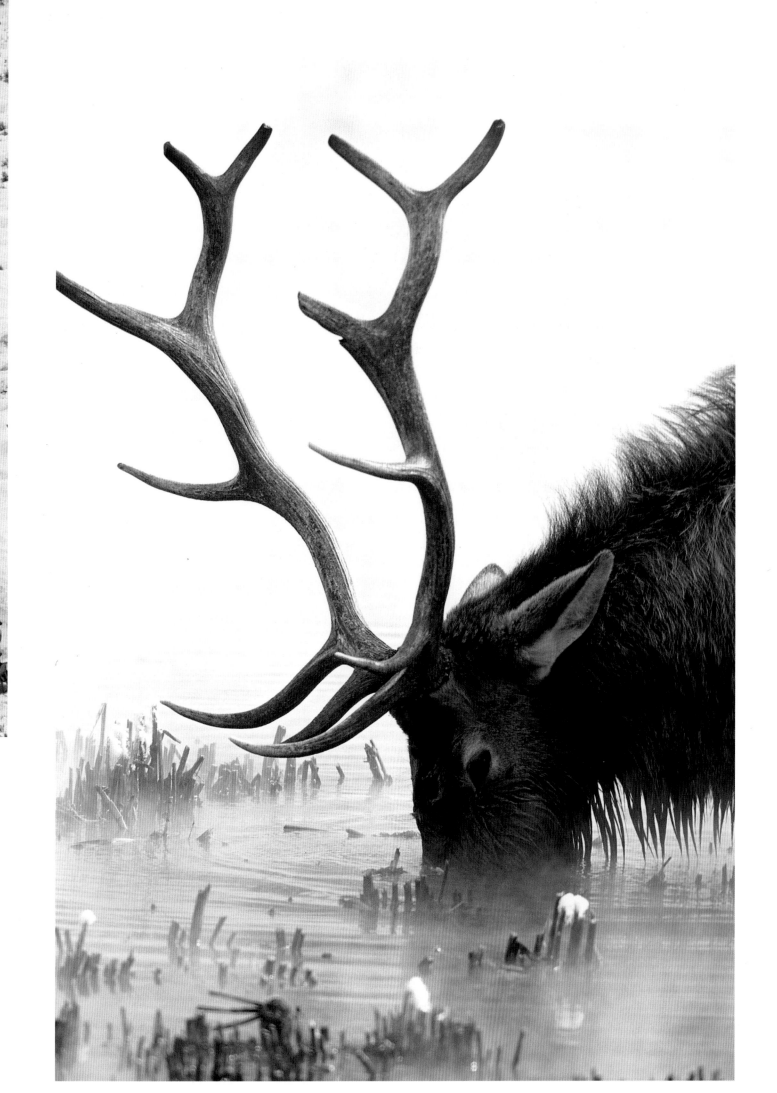

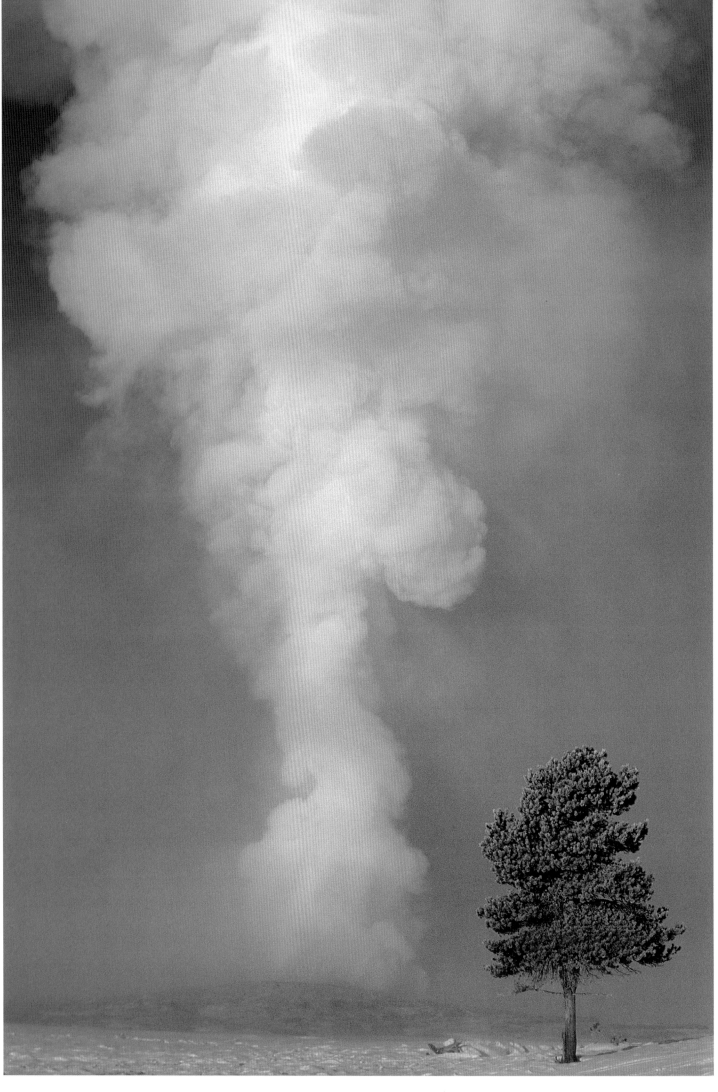

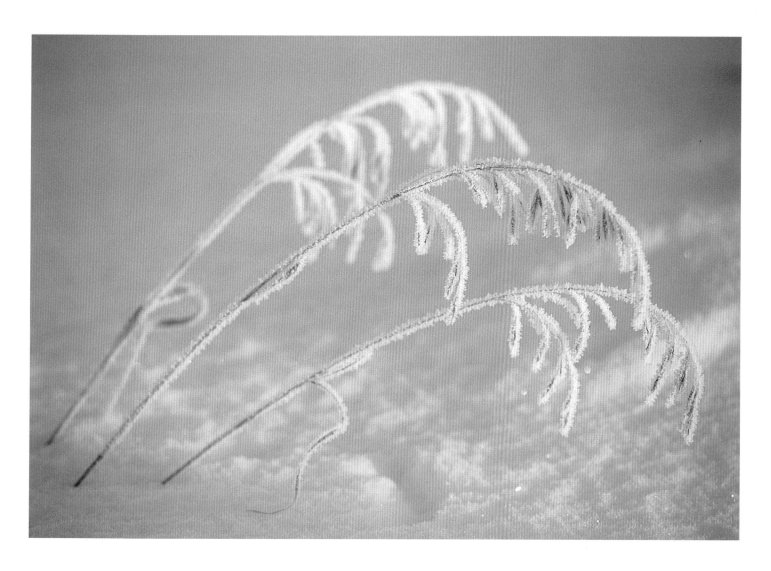

Old Faithful Geyser is one of the most famous natural features in the world. We stood on the east side of Old Faithful at sunrise in twenty below zero temperatures waiting for the sun to light the pine tree, hoping the geyser wouldn't erupt too soon. Eruption intervals vary from 30 to 90 minutes with an average of about 75 minutes. We were fortunate the sun illuminated the landscape before the geyser erupted.

The durability and resilience of grasses amaze me. They bend and twist in the wind. Things walk on them and lie down on them. Snow piles up and over them, and of course many things eat them. These seed stalks had survived all of this and were still standing above eighteen inches of snow. Heavy frost was pulling them down, but soon the wind and the little heat from the February sun would knock off the frost, and they would stand tall again.

Elk belong to the deer family, called cervidae, which are hoofed ungulates that annually grow and shed antlers. Bull elk carry their antlers through the winter, shedding them in March and April. I liked the round arc of this bull's antlers and the softness of the heavy snowfall. The snowfall also blurred out the background making the elk more prominent.

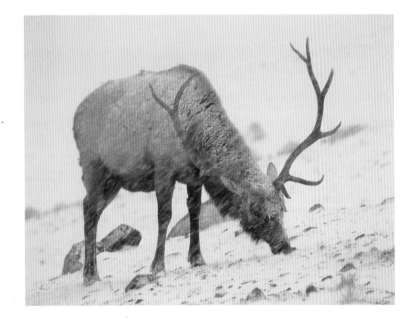

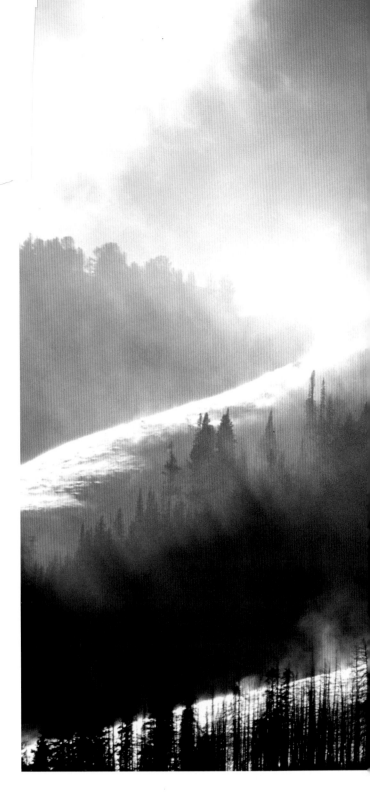

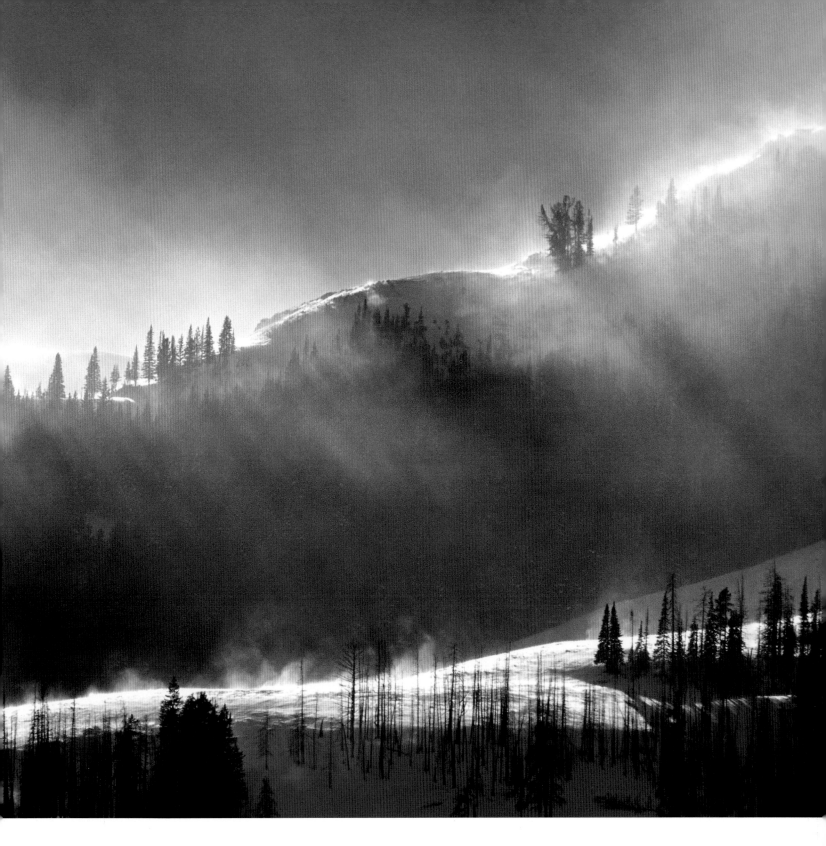

Specimen Ridge is the divide between the Yellowstone River and the lower Lamar River. Extensive fossil forests are preserved in the prehistoric volcanic ash and mud flows piled here. Cold-hardy lodgepole pine and Douglas-fir now grow on top of more than two hundred types of petrified trees, including subtropical species such as magnolia, maple, and avocado. The high, swirling snow blowing off this subalpine ridge illustrates how changeable and dynamic our earth is.

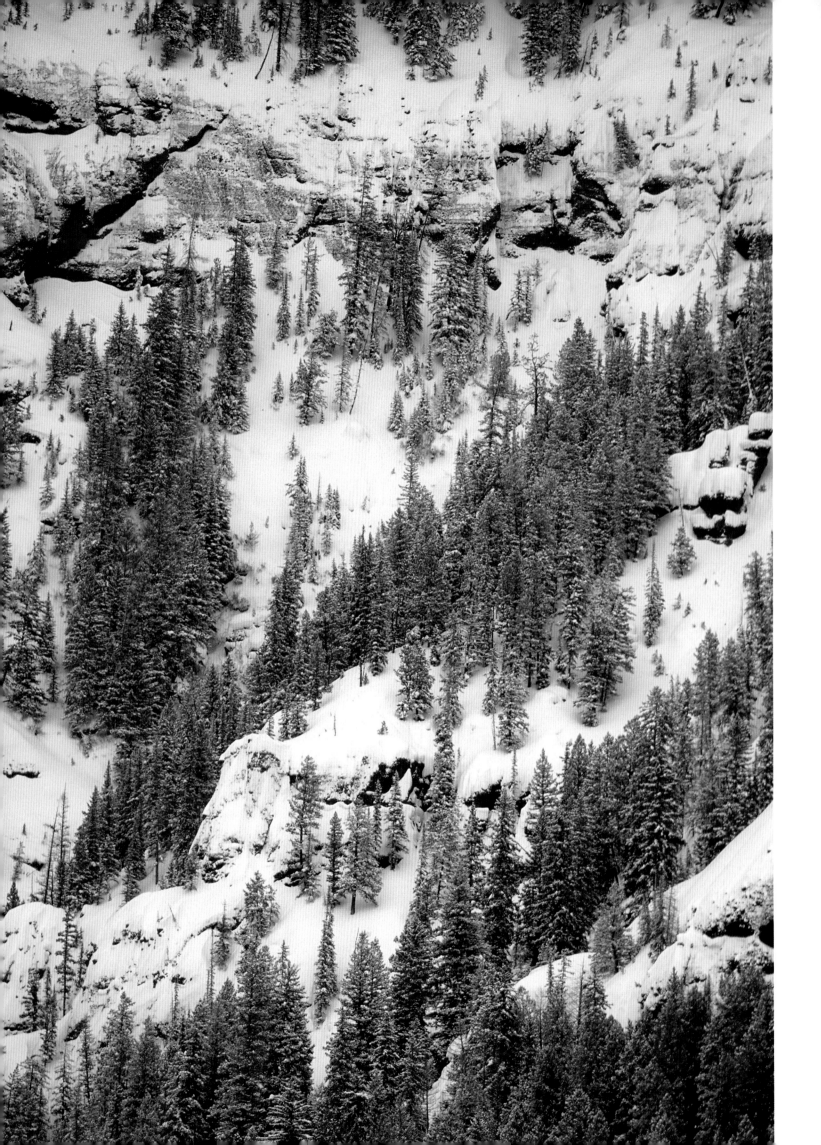

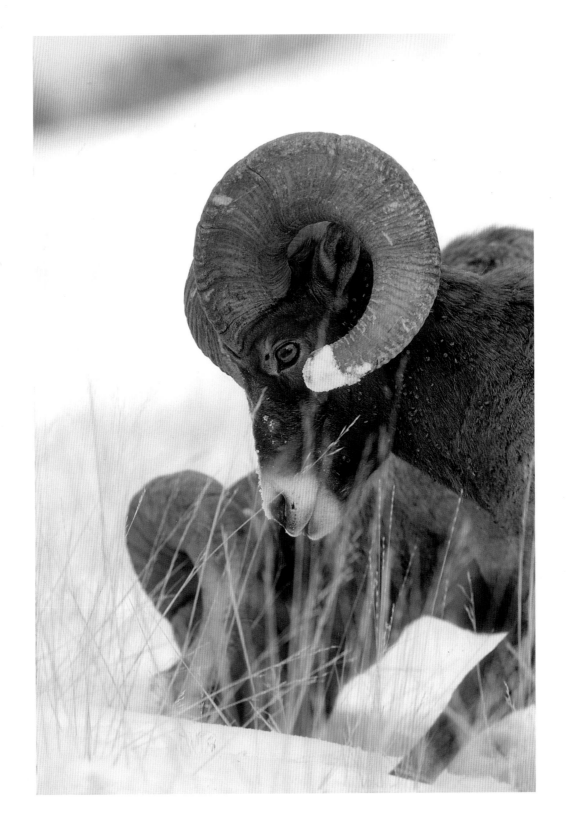

These two bighorn rams were very busy digging for grass using their front feet. They pushed away the snow with a circular motion and spent several hours at a time digging for lunch, pushing their noses into the freezing snow, happy to find cold, dry, brittle grass that they wouldn't have touched only a couple of months earlier.

A long ridge on the east side of Soda Butte Creek, the Thunderer got its name in 1885 because it seemed to attract a lot of thunderstorms. Few humans visit this mountain because of its steep, treacherous slopes. Even the trees seem to have a perilous hold on this volcanic escarpment.

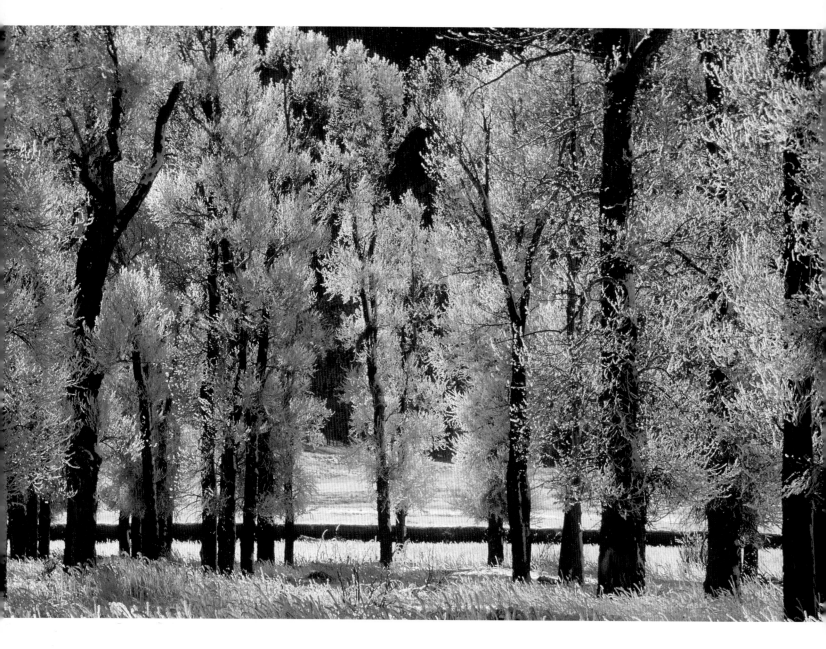

A cluster of trees like these cottonwoods attract people, whether it's summer or winter. It is part of our definition of a park to have a welcoming place for relaxation and rejuvenation. These stately trees show a sparkling beauty from the millions of radiant frost crystals on them.

Like a carpet of tiny feathers, these frost crystals grew on the flat end of a small tree branch. Each crystal is about the size of a pinhead. I am daily amazed at the wondrous things that occur in the natural world. Outrageous things go on every second that we will never see. The universe is little concerned with us, but I am happy on a day like this to be along for the ride.

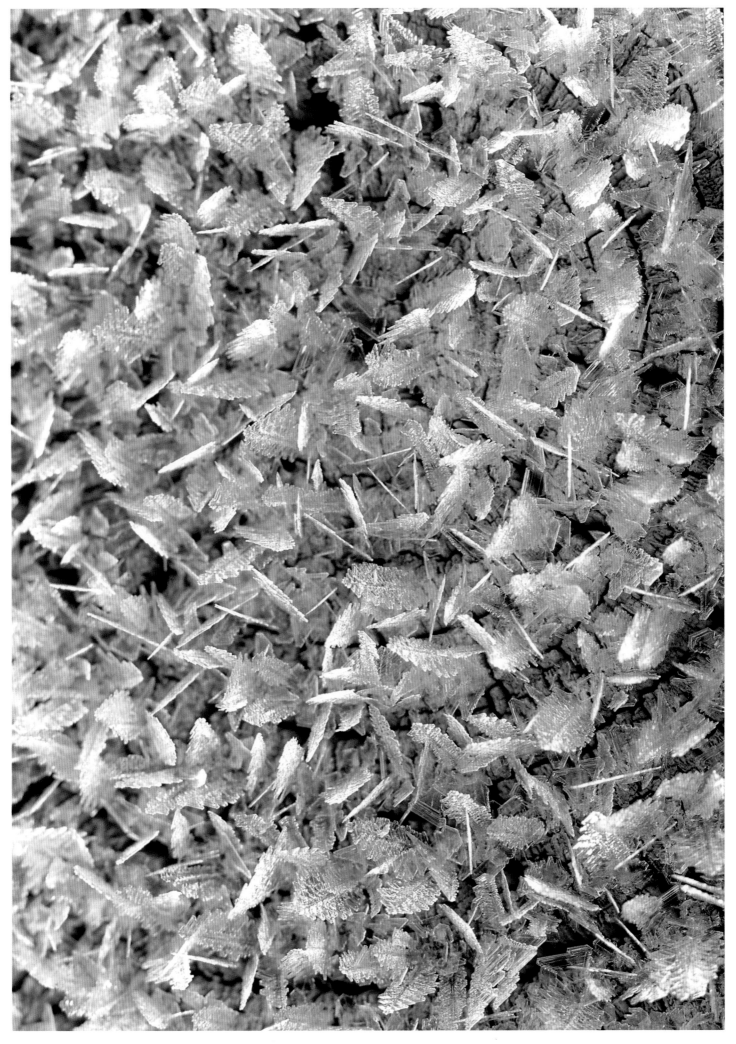

Bull elk carry their antlers nearly the entire year. They start to grow new ones within days of shedding their old ones in April. These two bulls were well fed and content on a pleasant January morning. They were evenly matched in size so this sparring or play-fighting lasted about ten minutes. They pushed and clattered their antlers together, dancing in circles around each other and around a tree. Once in a while an antler tine would pinch the other's ear or poke his jaw and he would cry out with a high-pitched, squeaky mew that did not sound very impressive for a 600-pound fighter.

Even when the major geysers are not erupting, they still produce great landscapes. Columns of steam climb hundreds of feet in the air. Wisps of fog drift silently along the snow, appearing and disappearing for no obvious reason. This breath from Old Faithful rose more than two hundred feet above the misty low fog.

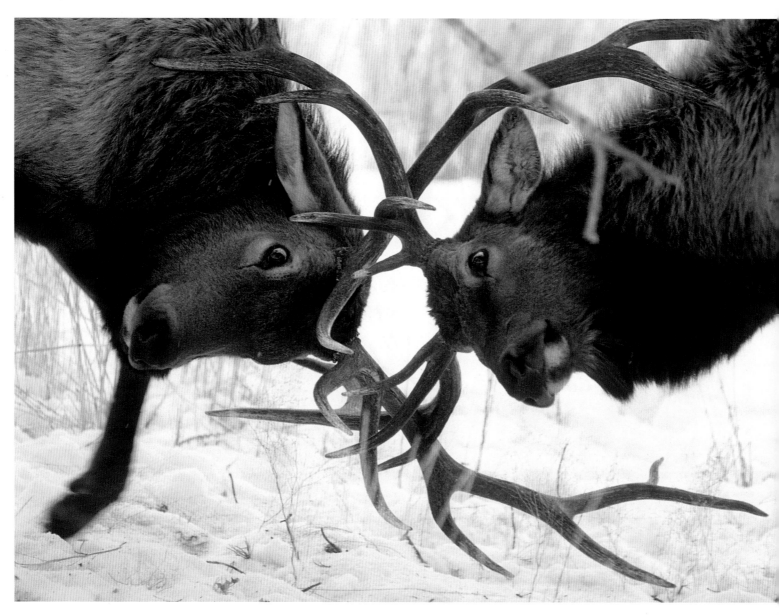

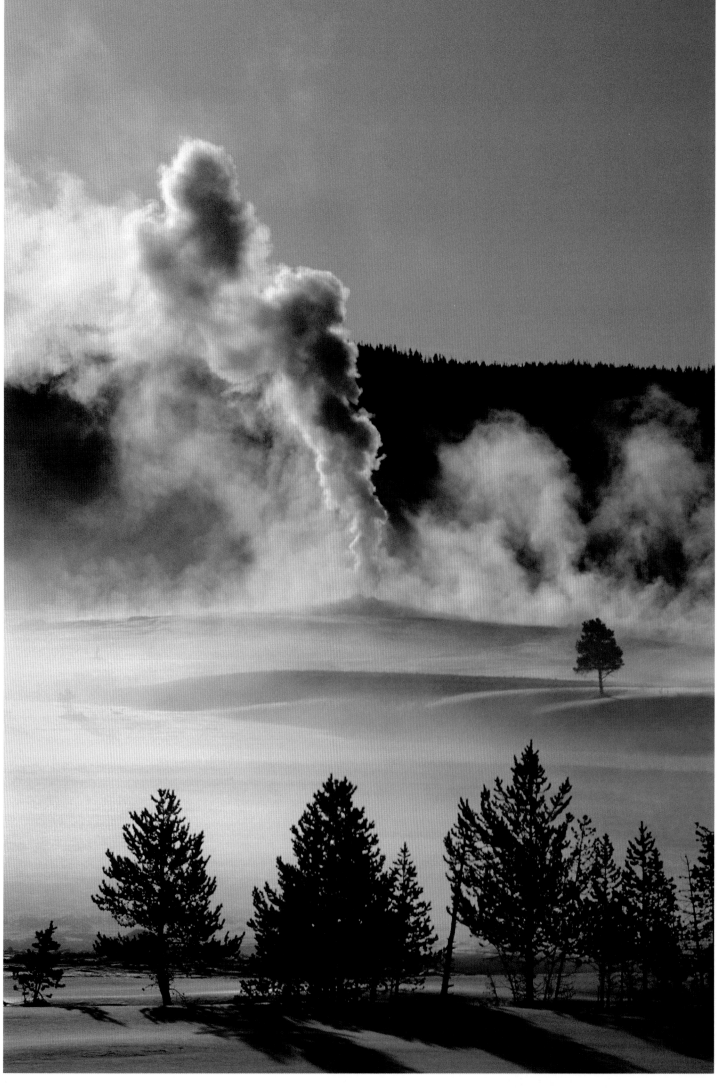

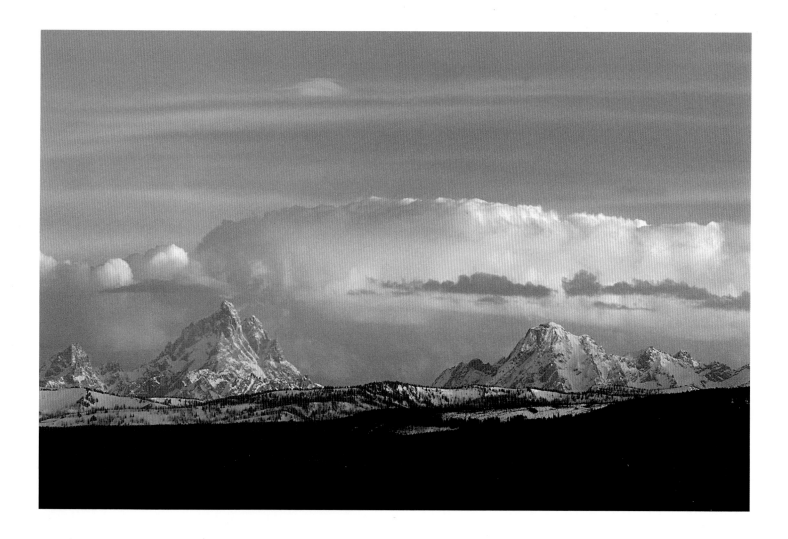

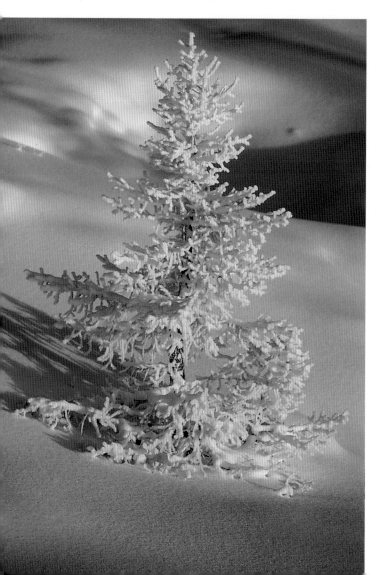

The tops of the Teton Range are visible nearly sixty-five miles to the southwest from Lake Butte, near the northeast corner of Yellowstone Lake. The Tetons project high above Yellowstone's Red Mountains, Big Game Ridge, and the surrounding plateaus and catch the last light of the evening.

This feathery, frosted tree stood just below Minerva Terrace in a deep snowfield. I was attracted by the contrast in textures as well as the nice sunrise color.

FACING PAGE: *The light just before sunrise can often be subtle yet the most dramatic of the day. About five minutes before sunrise, Electric Peak and the sky lit up from scattered and diffused light in the clouds.*

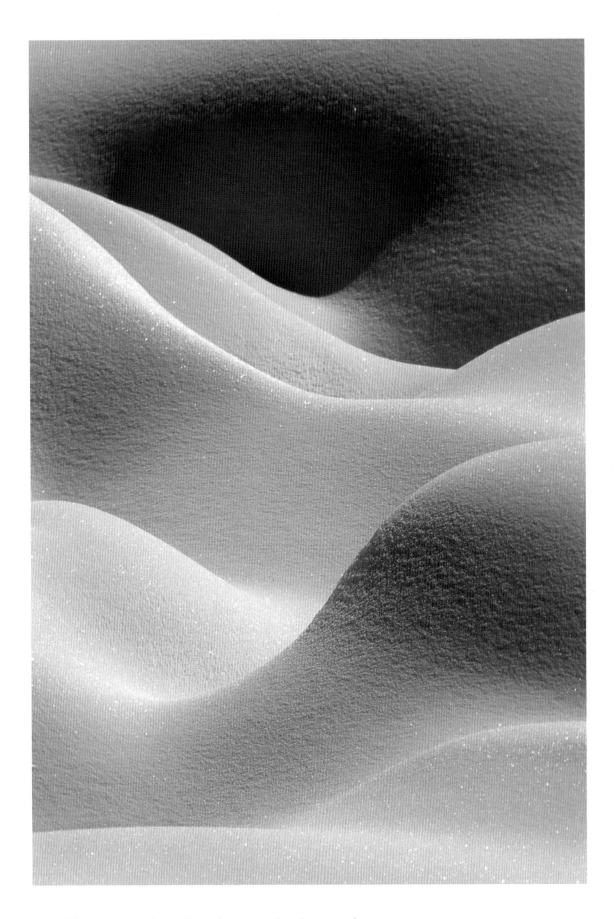

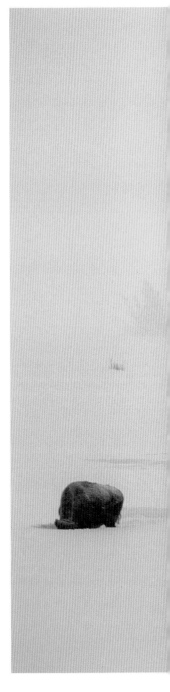

One of the interesting things about abstracts is that the sense of scale disappears. In a good abstract, pure form maintains the viewer's interest. It will not matter what the thing is, but it is still interesting to find out. These snow pillows are about two feet high; it is about ten feet from the foreground to the back of the image.

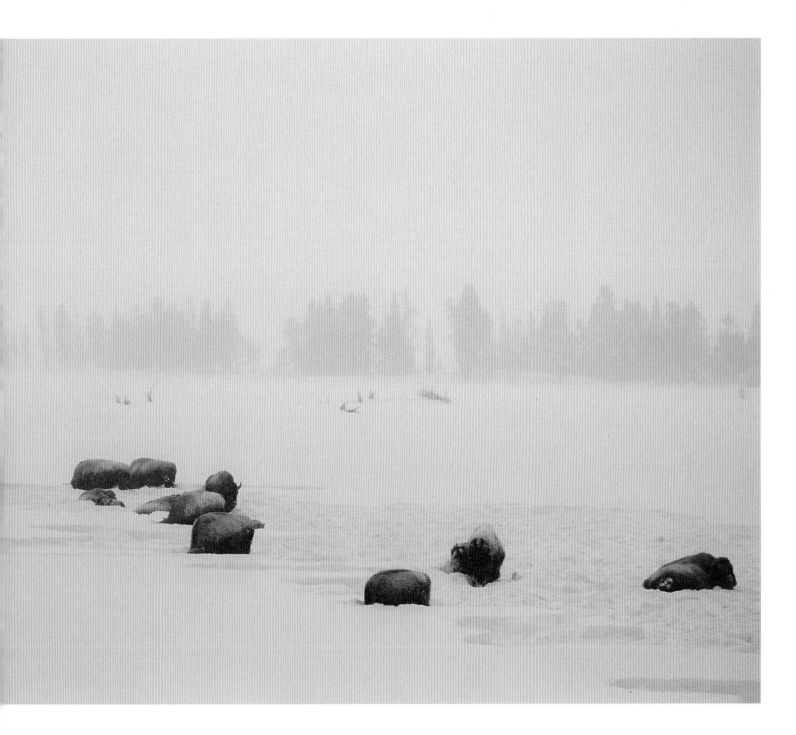

It was around thirty-five degrees below zero this January morning near Norris. When it is that cold it rarely snows. Most of the haze in this photograph is from the large steam cloud around Norris Geyser Basin. These bison were slowly pushing the heavy snow around, enduring the extreme cold and ignoring the light snowfall, trying not to waste any energy. Bison patiently wait out winter storms, letting the wind and cold batter them, relying on the heavy cape of hair across their shoulders and heads to insulate them from deadly cold.

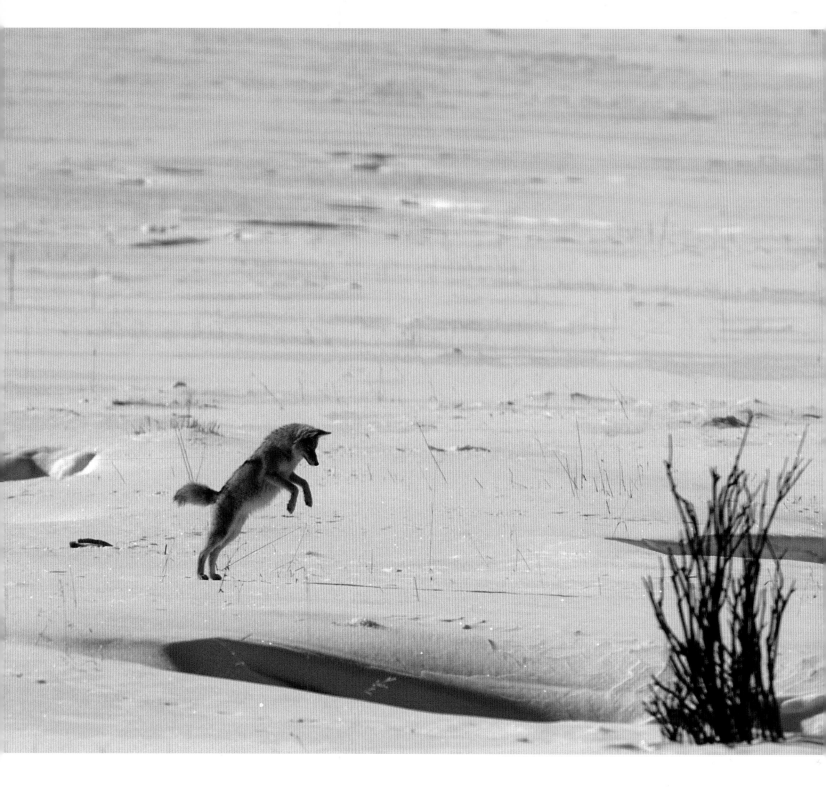

Coyotes, like people, will eat almost anything. This young female was walking briskly on top of crusty snow on a beautiful, sunny, winter afternoon. She heard a mouse scratching around on the ground about one foot below the surface. Quietly walking closer, tipping her head back and forth, she pinpointed the mouse's location. She jumped high in the air so her weight would break through the crust and pinned the mouse on the ground with her front feet. Picking up the live mouse with her front teeth, she flipped it over her head. The mouse landed on the hard snow and faced the coyote. The mouse had no easy escape and, obviously disoriented, ran between the coyote's feet. The coyote danced around and nipped at the mouse, flipping it in the air several times. Eventually the mouse just sat on the snow looking up at the coyote. The coyote stood on her hind legs and pounced once again on the quiet mouse. Then the coyote swallowed it head first and walked away.

When I stood in this field of snow in Hayden Valley, the surface was a gentle, rolling expanse with big hills an eighth of a mile away. I thought of those hills as obstacles until I saw and followed this set of mouse tracks. The little three-inch-high bump on the snow was a significant terrain feature to him. In his explorations he must have thought, "Hmm, what's on the other side of this thing."

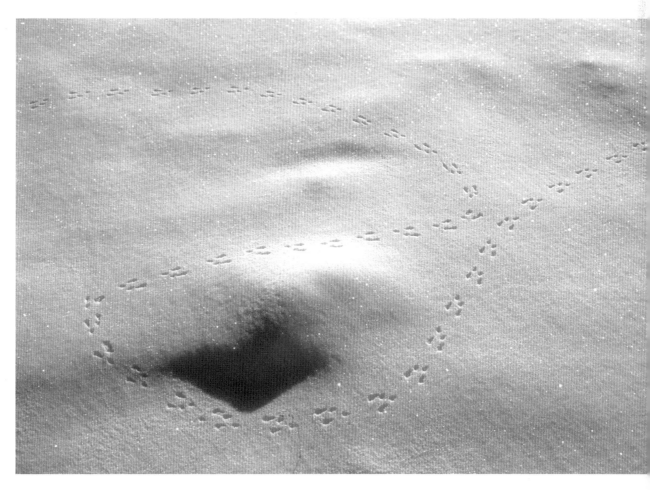

Elk had been traveling across this hillside at different times over the past week. A half-hour after sunrise this bull was traveling north, following older elk tracks. The angle of the sun was slightly higher than the angle of the slope, so the elk's shadow stretched out below him almost twice as large as he was. The other elk tracks add nice depth and texture to the landscape.

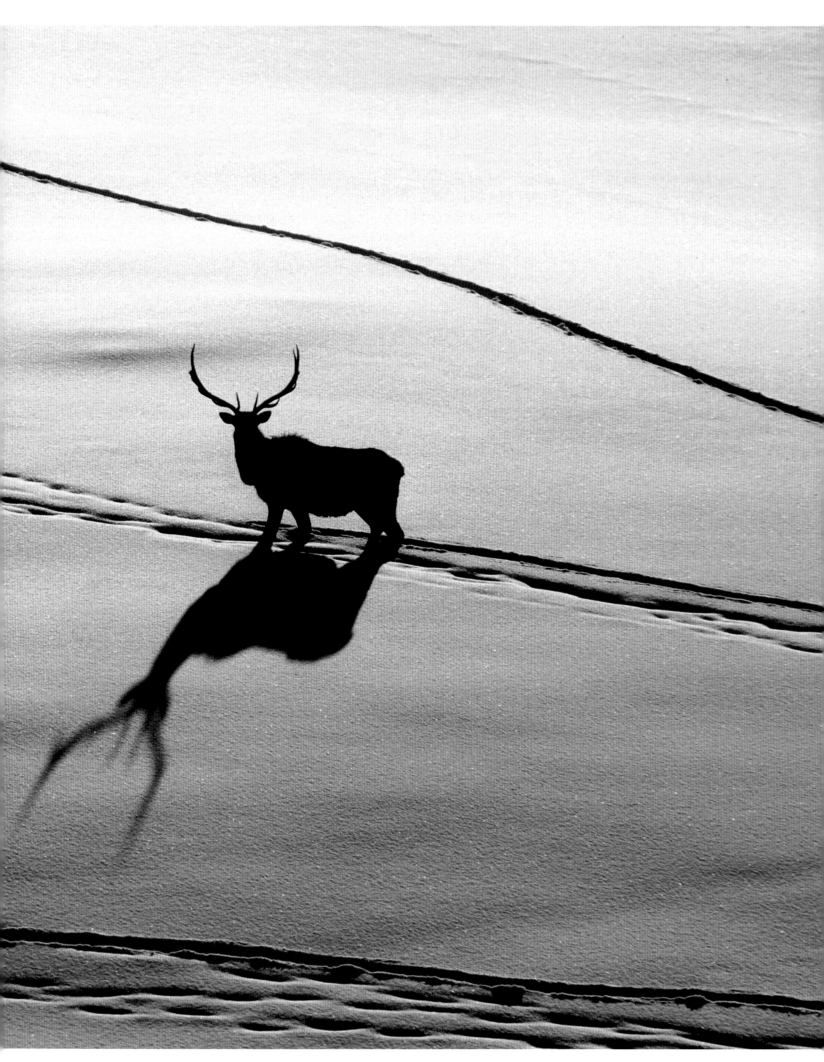

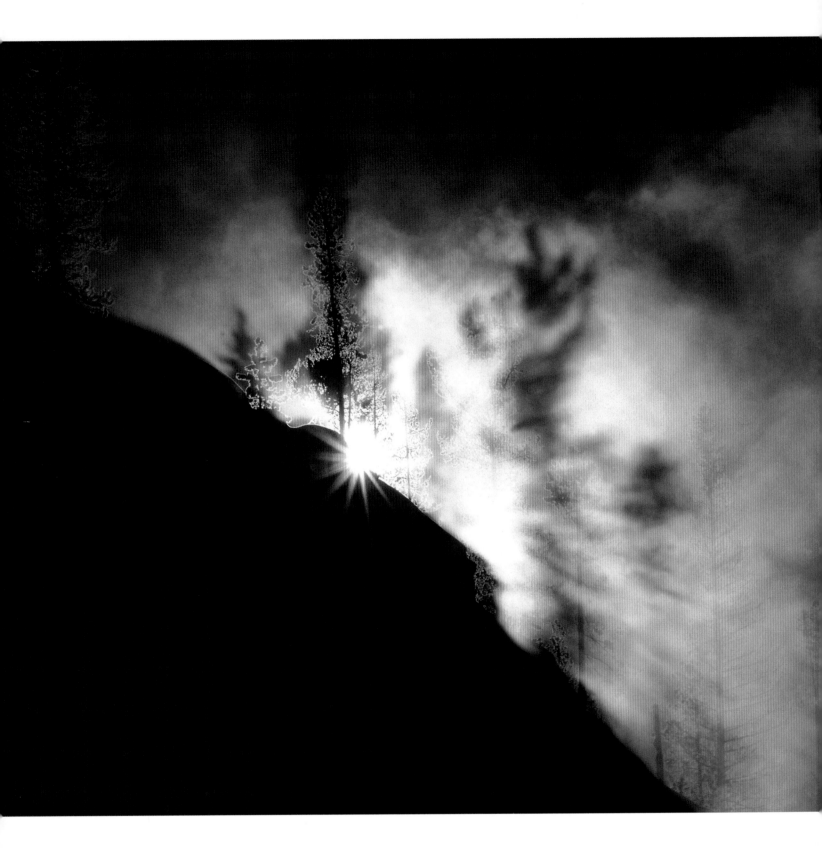

Steam from the warm Firehole River drifted up the dark east wall of Firehole Canyon into the morning sun. Shadows of small trees were magnified and projected onto the face of the steam cloud. The shadows floated in the air until fingers of light pushed them down into the darkness of the canyon.

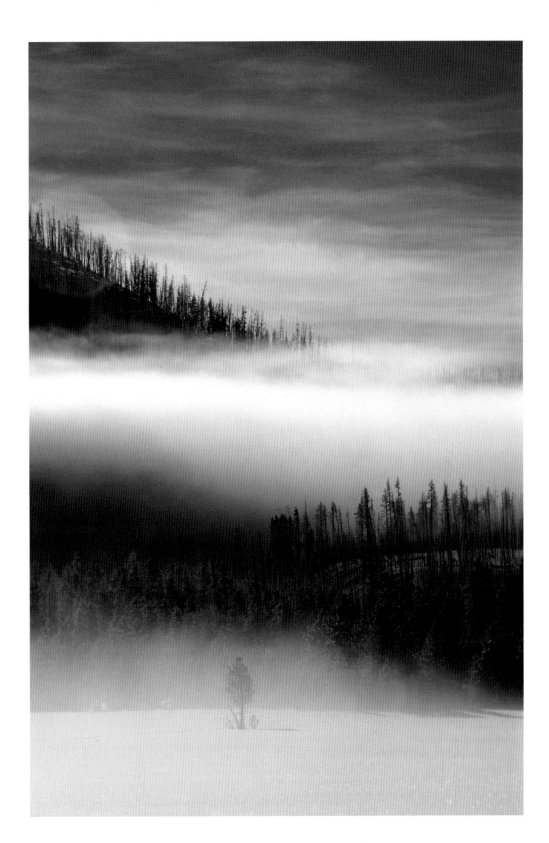

Gibbon Geyser Basin, Monument Geyser Basin, and Artist Paint Pots produced a multi-layered fog bank in Gibbon Meadows. One layer stayed along the ground moving north. Another drifted north of the ridge about 100 feet above the meadows and vanished off to the east. The other fog bank was thin, and it scattered into the blue sky about 1000 feet above the ground.

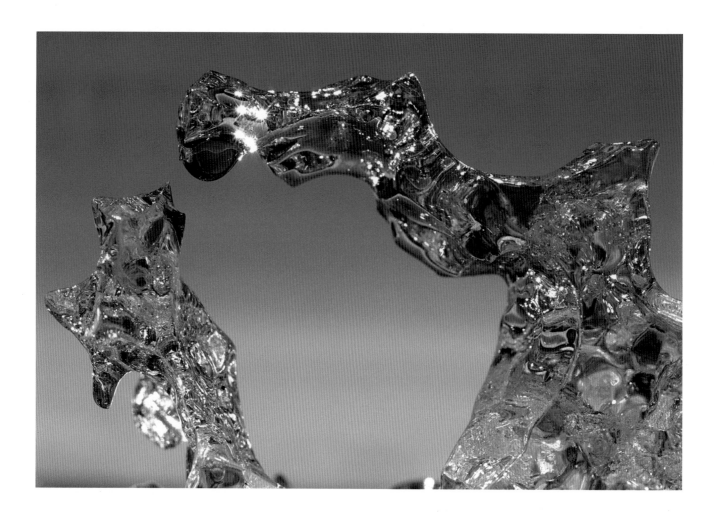

For about five months of the year Yellowstone Lake is frozen over except for a few areas above hot springs, geysers, and other thermals. In late winter as the sun gets warmer and softens the ice, wind will start to break up the ice with waves from the open water. Pieces of ice are pushed to the shore and stacked on top of one another. This is a macro photograph of a ten-inch piece of this ice melting in the sun.

Waterfalls do not freeze completely in the winter; a shell or crust of ice usually forms over the surface and hides the water that continues to go over the fall. Undine Falls is mostly hidden under such ice all winter except for the bottom four to six feet. The night before I took this photograph, a cold front had gone through. The cold night air had formed a thin shell of new ice over the moving water at the base. I like the softness of the water contrasted with the delicate, lacy new ice and the sturdy old ice.

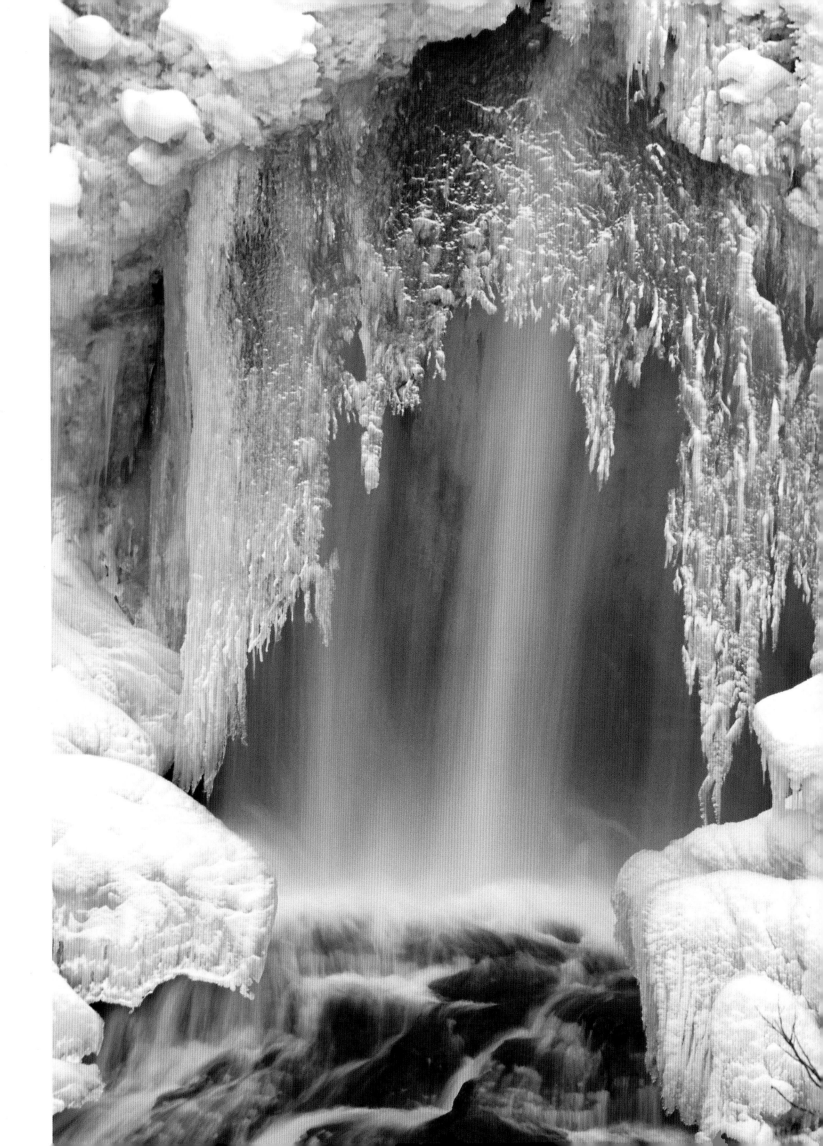

This bison bull was standing close to the sunny south side of Soda Butte. He was soaking up as much heat as he could by standing broadside to the sun and using the bare travertine rock as a reflector and wind block. I timed my photograph to catch the plumes of breath from his nostrils as he exhaled in the below-zero cold.

Roaring Mountain is a large, mostly quiet hillside covered with fumaroles, geothermal features that vent steam from groundwater coming in contact with heated rock. Fumaroles can roar, whistle, and hiss when there is a constriction at the mouth of the vent. With dozens of fumaroles, Roaring Mountain has occasionally lived up to its name, but now it produces mostly delicate plumes of steam drifting across the barren, acidic hillside.

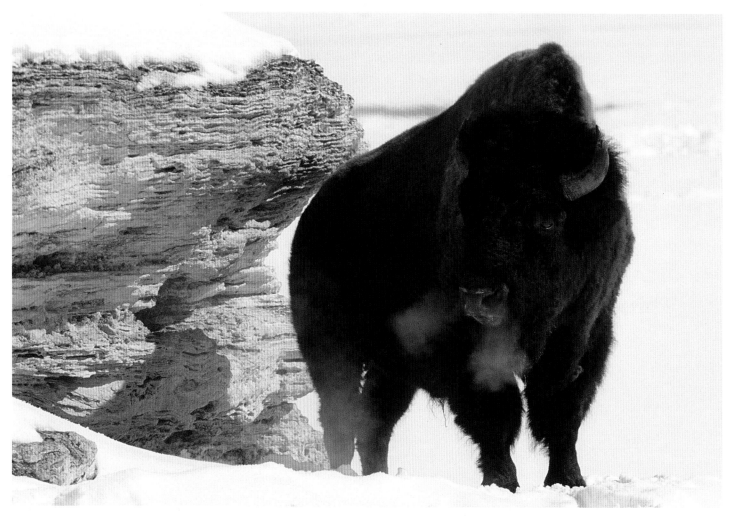

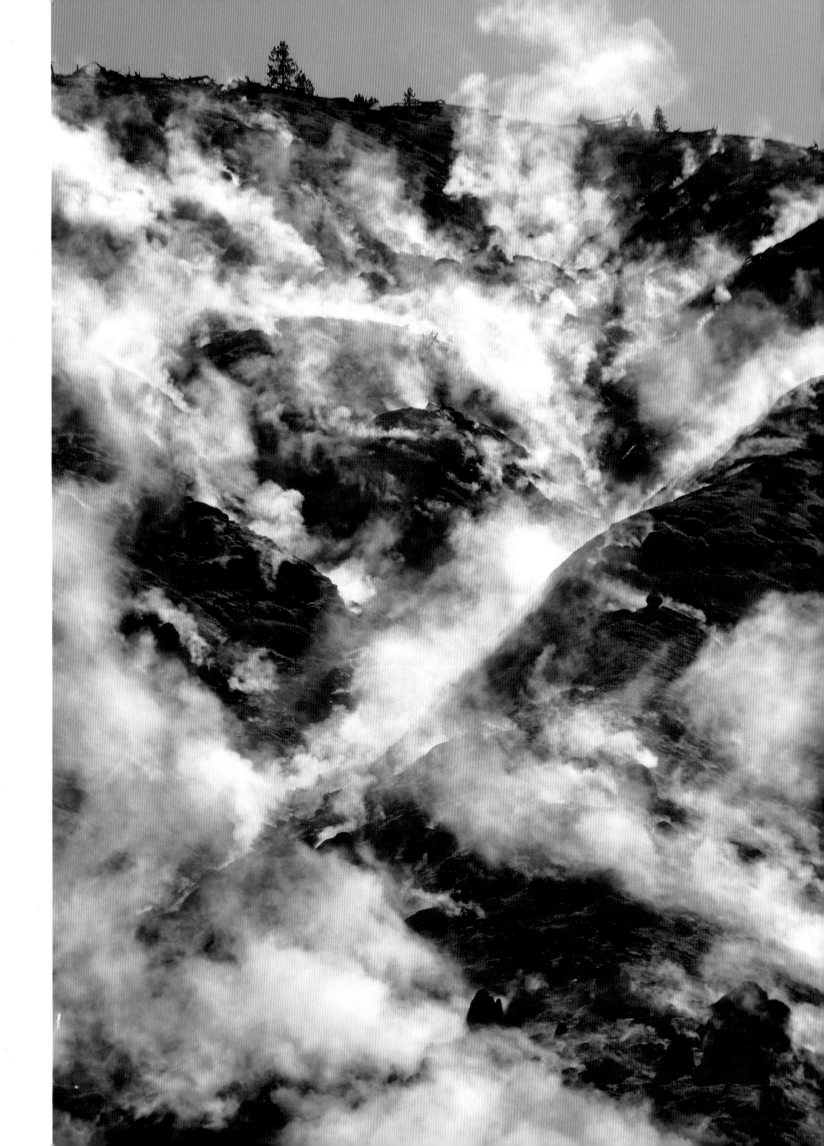

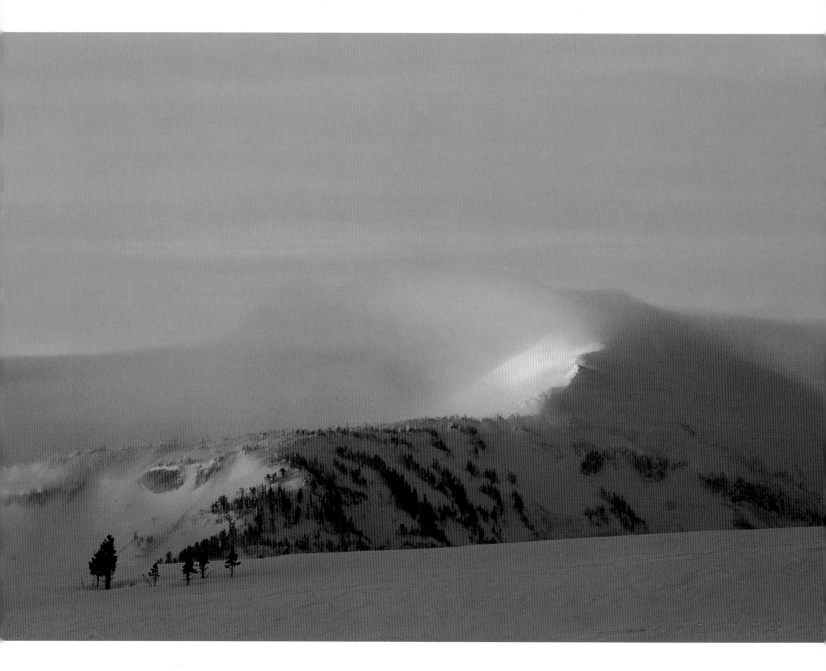

Antler Peak in the Gallatin Mountains was glowing at sunrise from a narrow beam of light. I liked the soft cloud above the color and the subdued texture on the foreground ridge. This photograph was made with a 500mm lens so the landscape is compressed. The low ridge is several miles from Antler Peak.

There is always fog in the winter mornings along Obsidian Creek. The early morning sun illuminated this fog and made it glow while the trees were still in the shade.

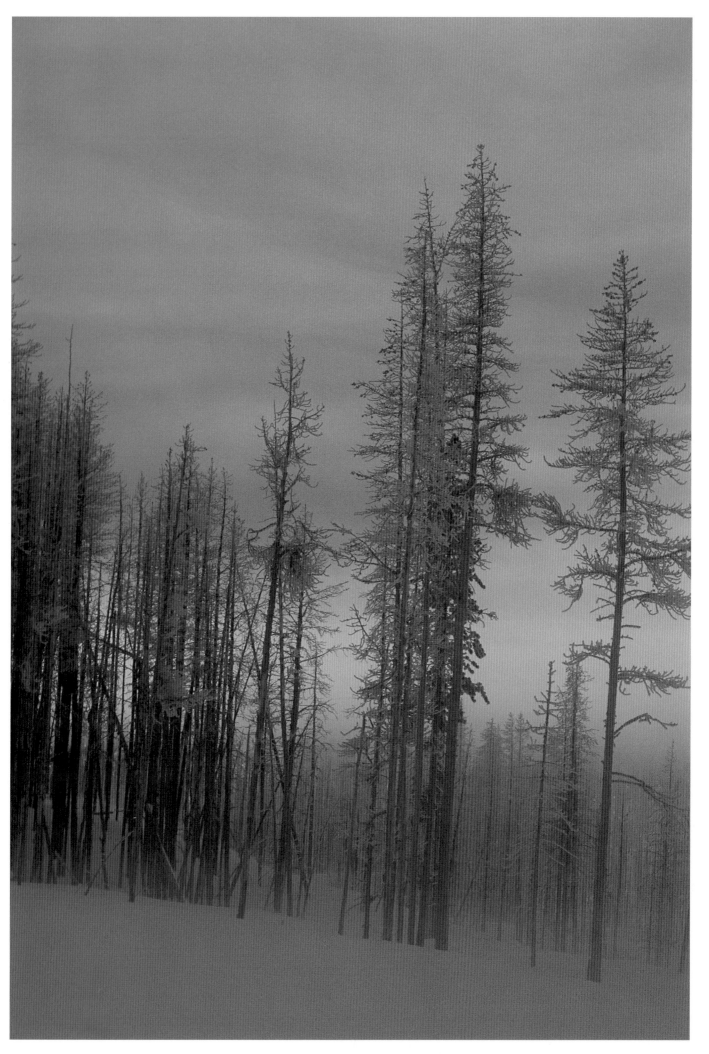

In midwinter calves are rarely nursing, but they still stay very close to their mothers. The cows are teaching them, by example, things like migration routes, where to find grass and water in deep winter, and how to deal with predators and other threats. Some cows are very affectionate with their calves, licking and grooming them.

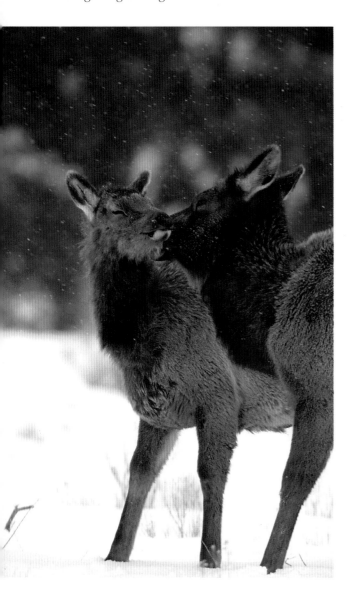

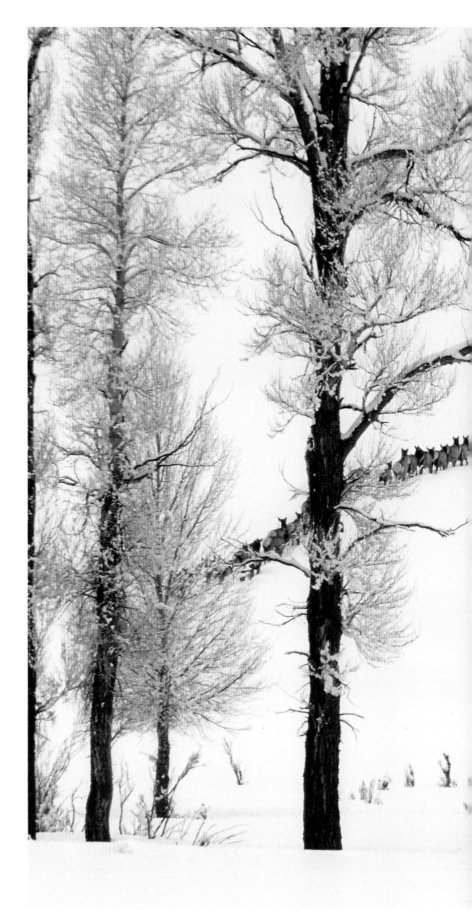

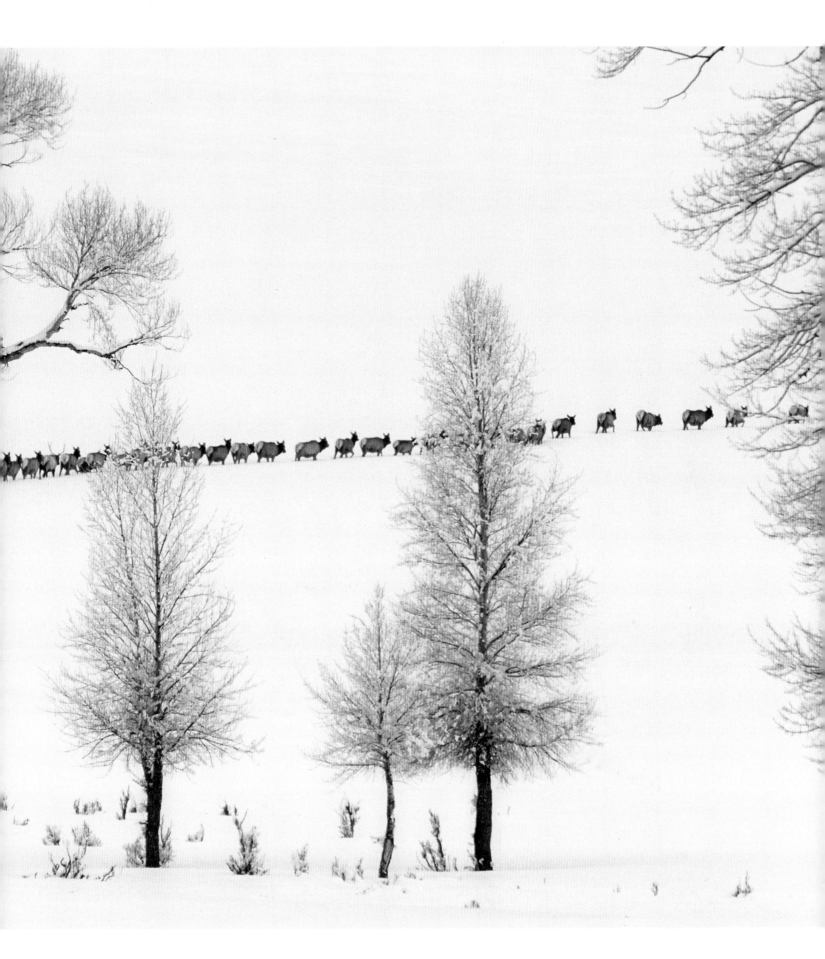

Elk herds travel as efficiently as possible. They choose routes that have the best footing and consume the least amount of energy. These elk were moving across open land along the Lamar River. They were not in a hurry, and the most efficient way to travel was single file, letting the first few individuals do all the work of breaking trail through the deep snow.

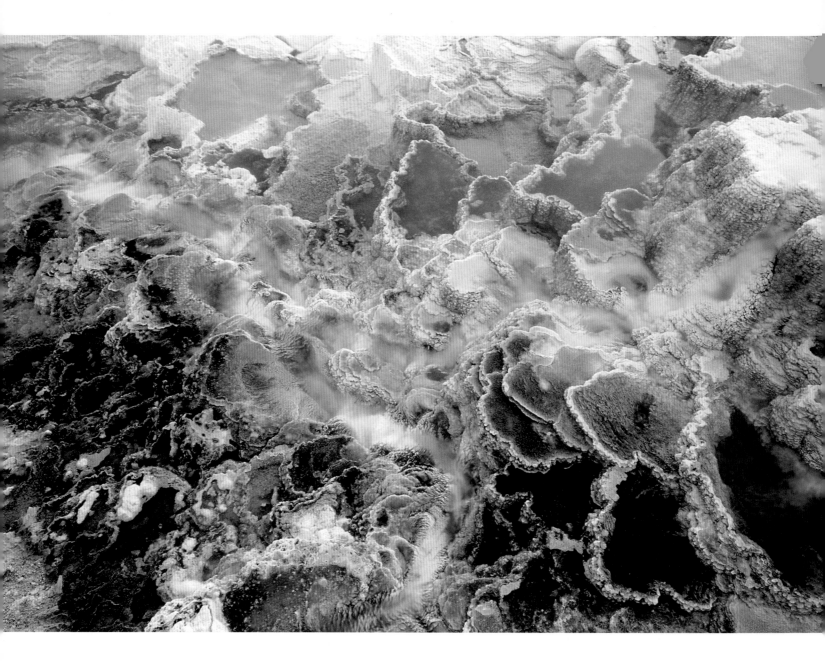

The runoff from Minerva Spring is colorful and heavily laden with minerals. Minerva was aptly named for a Roman goddess presiding over handicrafts, arts, and science. In the 1880s and 1890s wooden racks were built along the face of this spring and the water was diverted over them. Objects were hung on the racks and became coated with the dull, white travertine. These "coated specimens" were sold as souvenirs. This practice was later prohibited.

Beehive Geyser is a cone-type geyser shooting water more than 200 feet high. The rounded cone looks like an old-fashioned beehive. The geyser erupts infrequently, but occasionally it has regular cycles of 12 or 24 hours for several days. When it erupts it makes a wonderful roar and throws water in a vertical plume. The mist drifts over the boardwalk, creating a rainbow when the sun is right. The water is cool by the time it falls back to the ground and tastes good.

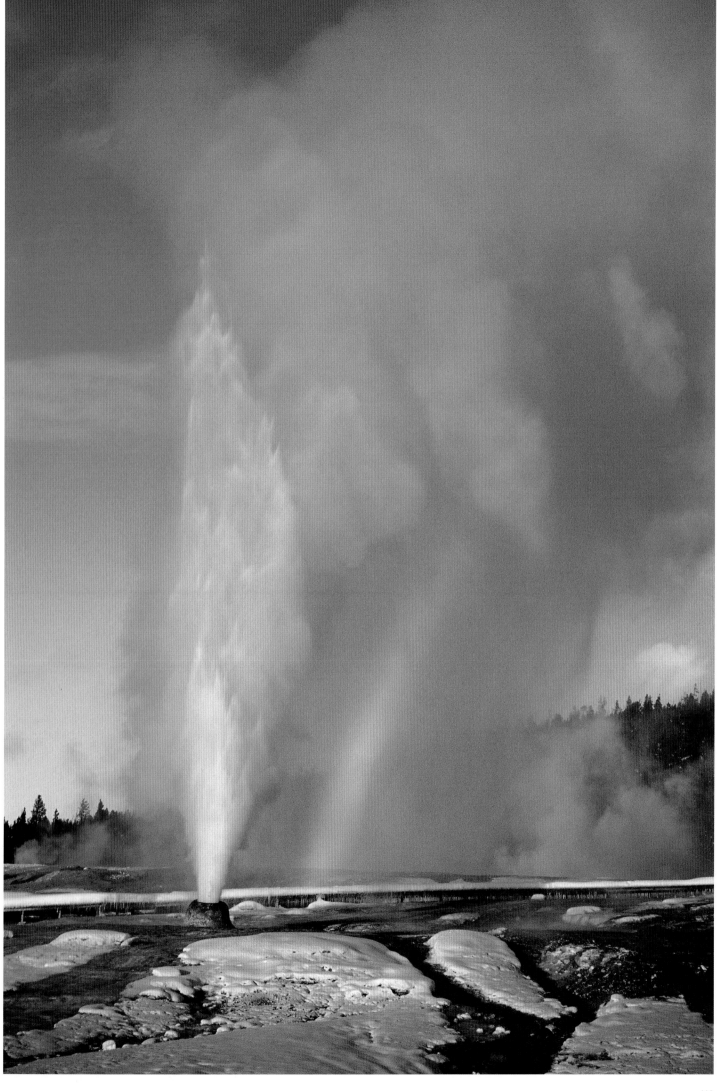

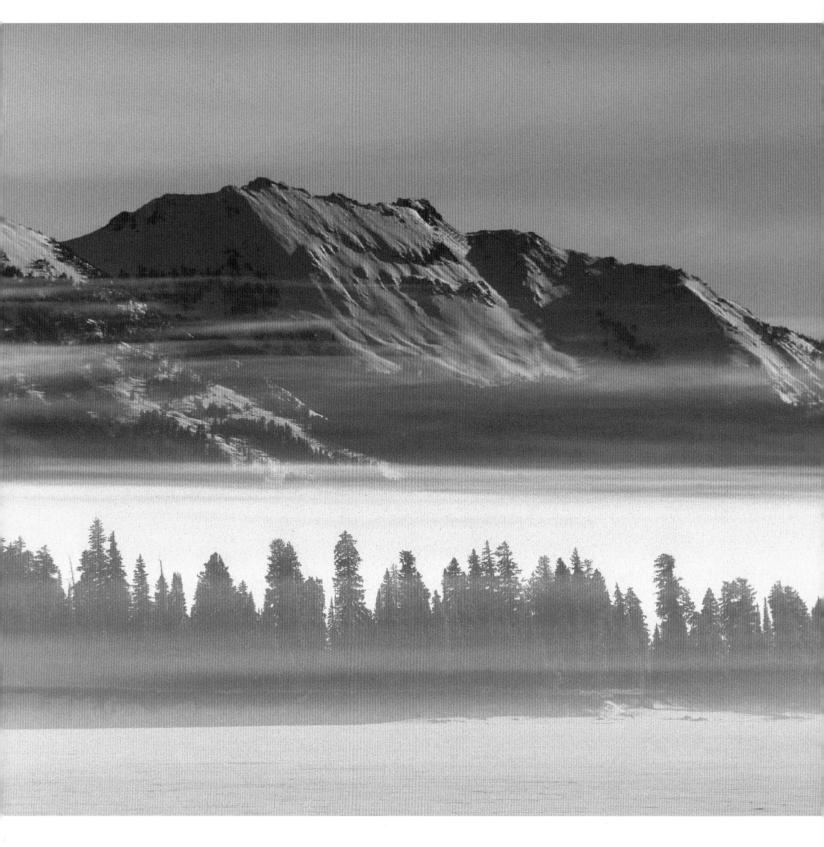

Stevenson Island, named after a member of the 1871 Hayden survey party, is the second largest of the seven islands in Yellowstone Lake. It is a low sliver of land about one mile long, seen here as a row of trees in the fog. Mount Chittenden rises ten miles beyond the island on the eastern boundary of the park.

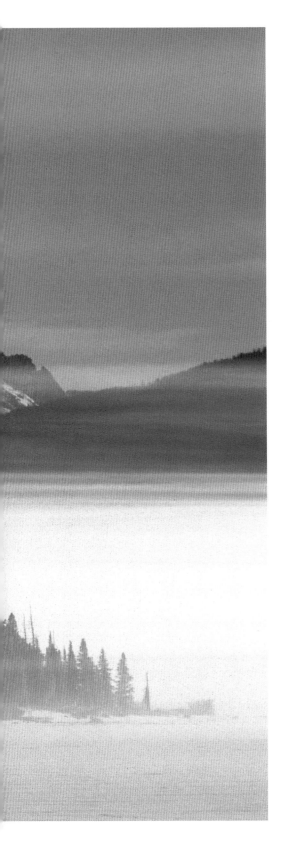

These trumpeter swans were spending most of the winter along
the Yellowstone River between Fishing Bridge and the Upper
Falls. I observed them sleeping or resting for ten minutes before
they started to stir. Two stood up and preened their feathers,
flared out their wings, and settled back down. After a few more
minutes one of the adults got up, walked to the open water, slid its
breast down over the edge of the ice, and paddled away upstream.
The rest reluctantly followed. The gray cygnets were the last to go.

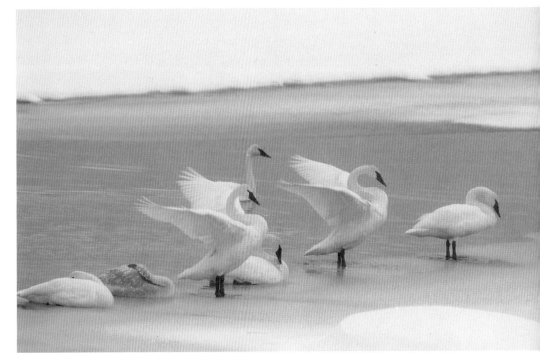

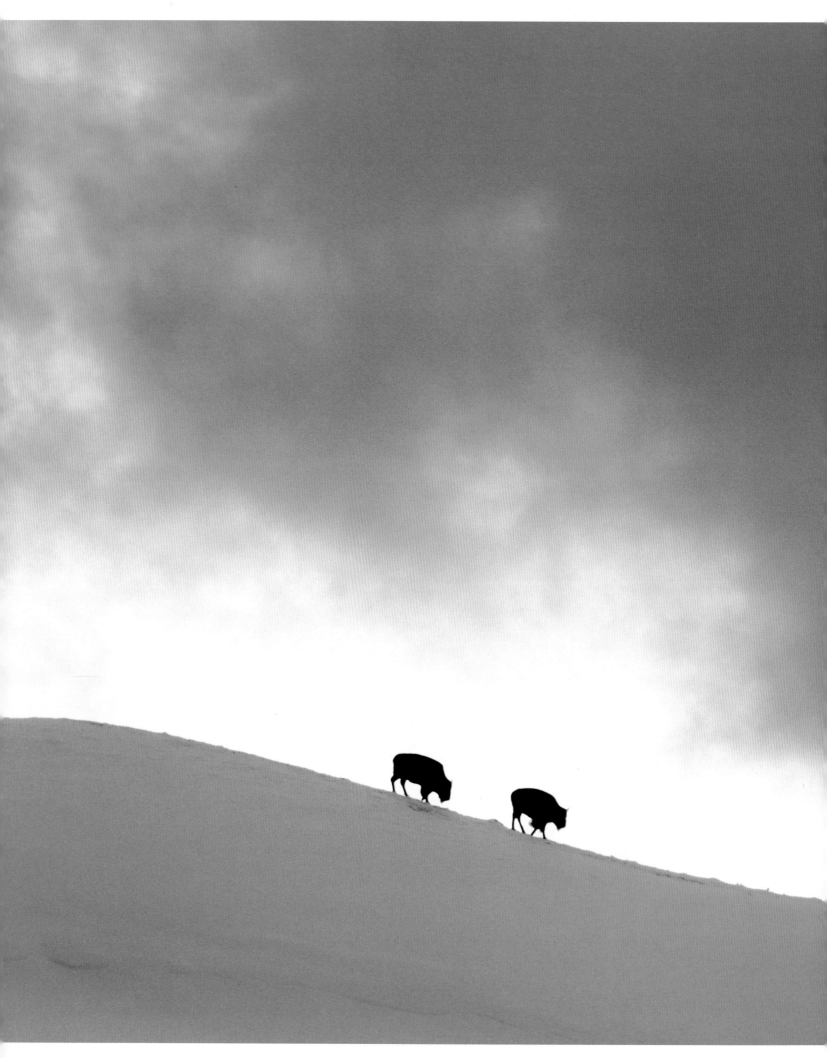

Two young bison were walking slowly along this ridge in the middle of the Hayden Valley. There was a bare section on the ridgetop and deep snowdrifts to their right. They were here because of the exposed vegetation and easy travel routes. I like the cloud above them and the stark, graphic shape of their bodies on the ridgeline.

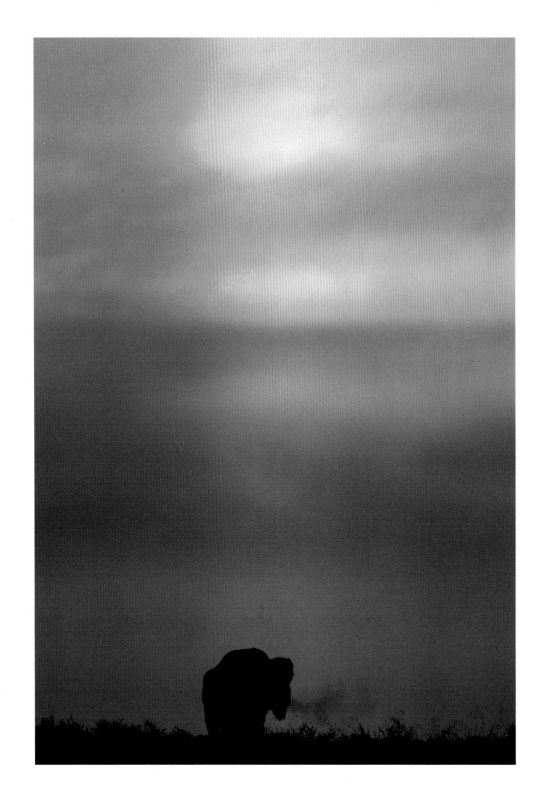

A sundog or parhelion is a rainbow in atmospheric ice crystals on each side of the sun. Other rainbows are only visible as you face away from the sun. I'm sure this bison did not know I was moving around him in order to place him in front of a sundog.

If I had only one hour a day to photograph, I would start ten minutes before sunrise. During this hour the light is often the best of the day; the air is clearer, cooler, and quieter; wildlife is more active; and fog and mist are visible. Old Faithful was erupting in the cold, still air. The plume of steam rose straight up for three- or four-hundred feet.

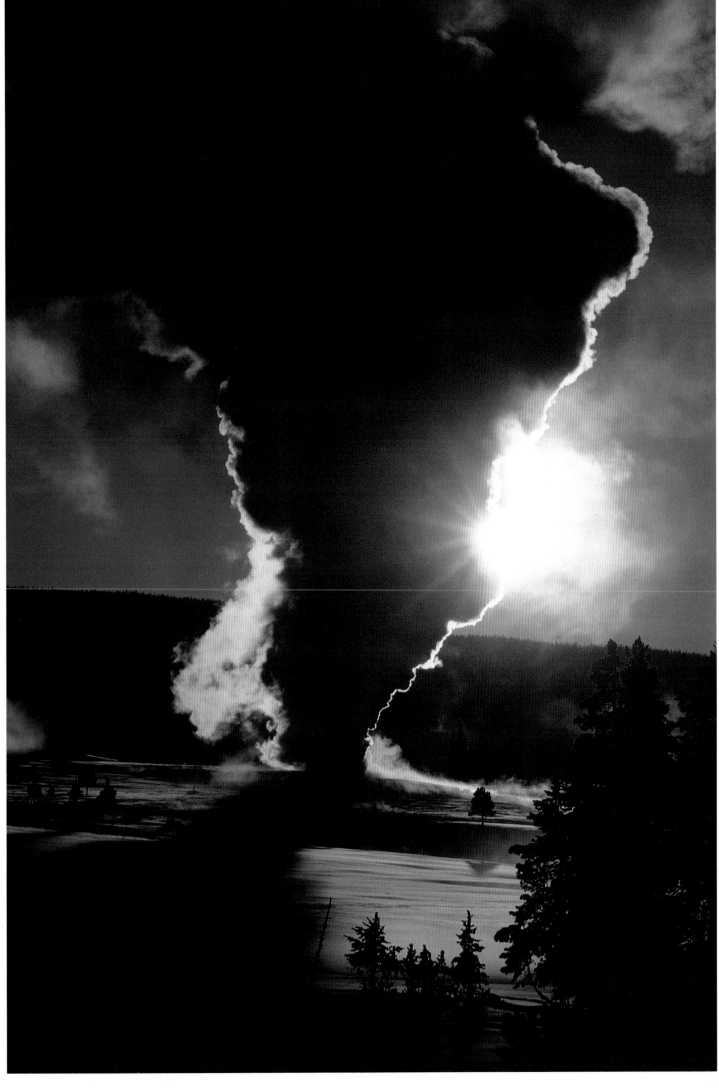

ACKNOWLEDGMENTS

THANK YOU TO EVERYONE WHO HAS SUPPORTED MY PASSION FOR YELLOWSTONE AND MY WORK.

Most importantly, to Bonnie, who still doesn't understand why I like to sleep on snow banks, for her encouragement, cookies, and love.

To my backcountry skiing partners: Wayne Yankoff, who joined me and learned with me on most of my first serious winter trips; Larry Raffety, who traveled every winter with me for a dozen years to see a new part of the Yellowstone backcountry; Brad Hicks and Jack Heckles, who so far have been willing to go with me only once; and Brian Chan and Dave Long, who waited for me to heal from an operation so I could join them on a trip from Bechler to the Northeast Entrance last winter.

To our Wilderness Photography Expeditions clients, most of whom are my friends now, too. For years they have told me, "Do a book!"

To Chris Cauble, who was willing to start a publishing company with this book.

Finally, thank you to everyone in the past 130 years who worked to establish and keep Yellowstone National Park for all of us, and for all who will work in the future, for the next ten thousand years, to preserve Yellowstone and wilderness: our ultimate source of beauty, life, and spiritual health.

ABOUT TOM MURPHY

TOM MURPHY HAS TRAVELED THE WORLD to photograph wildlife and wild places, but his home and his heart are in the Yellowstone area.

Raised on a cattle ranch in South Dakota, Murphy was drawn to the Rocky Mountains and its wildlife. He graduated from Montana State University with a degree in anthropology and spent many years combining photography with anthropological fieldwork.

In 1978 Murphy established a photography studio in Livingston, Montana, 55 miles from Yellowstone's northern entrance. From there, Murphy has traveled to the Arctic, Antarctica, Alaska, Costa Rica, Mongolia, East Africa, and other wild locations. His images have appeared in *Life, Newsweek, Audubon, National Geographic World, Outdoor Photographer,* and many other magazines, newspapers, books, and calendars. In 1998, Murphy's digital video footage was used to produce the video *Discovering Yellowstone,* which won a prize for excellent photography at the prestigious International Wildlife Film Festival. Murphy has conducted photography classes from New York to Los Angeles.

In 1986 Murphy launched Wilderness Photography Expeditions with his wife, Bonnie Hyatt-Murphy. It is a unique business that teaches natural history photography in the field with Murphy as the guide and instructor. Most expeditions take place in Yellowstone, where Murphy was the first person licensed by the National Park Service to operate photography workshops in the park. One of the reasons he started the business was to give something back to wildlife and wild lands and to encourage their preservation, a purpose appreciated by clients who come from all over the world. For more information on these workshops, write Wilderness Photography Expeditions, 402 South 5th Street, Livingston, Montana, 59047, or phone 1-800-521-7230, or visit the web site at www.tmurphywild.com.

Murphy spends 80 to 100 days in Yellowstone each year. He once skied alone 125 miles across the breadth of Yellowstone during one of the worst winter storms of the decade. In fact, winter in Yellowstone has always been one of Murphy's specialties. Appropriately, *Silence and Solitude: Yellowstone's Winter Wilderness* is Murphy's first book.

North Twin Lake has a thermal on the west shore just below a steep ridge covered with lodgepole pine. A skim of ice formed where the water was colder, and the vertical lines are the reflections of tree trunks in the open water.

TECHNICAL INFORMATION ON THE PHOTOGRAPHY

ALL THE IMAGES IN THIS BOOK were made with 35mm equipment, and I use very few lenses. My largest telephoto is a 500mm f4, and occasionally I use it with a 1.4 teleconverter. My other lenses are an 80-200 f2.8, 20-35 f2.8, and a 105 macro. I use cameras with motor drives, which I feel is essential for wildlife photography.

Modern 35mm cameras require batteries. If a battery only runs the meter, the battery will normally last about a year. Other motorized functions such as film advance, rewind, motor drive, and auto focus require considerable current. A new set of batteries to run all of these operations in Yellowstone's winter cold may only last ten to twenty rolls of film. To conserve batteries, I rarely use auto focus, and I manually rewind my film. With a set of new AA batteries I typically shoot forty rolls of film in the winter compared to fifty rolls in the summer. I don't try to keep the batteries warm; if they get weak, I change them. I have found that fresh batteries work better than my bare fingers at 30 below zero.

I use tripods ninety-nine percent of the time, even though they are cold, heavy, and awkward, and they pinch my fingers. Monopods, gunstocks, and handholding are faster, but many of the photographs will be blurry. A ball head and quick-release system are necessary to respond quickly to wildlife. I wrap the top sections of the tripod legs with closed-cell foam and duct tape for two reasons. First, the foam provides insulation for my fingers, and second, the foam provides padding when I carry the tripod and camera on my skinny shoulders.

I use slow, fine-grained, color transparency films. The older images in this book were made on Kodachrome 64. In the past ten years I have used Fuji films almost exclusively. Fuji Velvia, Sensia, and Provia are excellent films with a good color palette and fine grain. Velvia, the slowest at 50 ISO, is great for Yellowstone's winter landscapes because it maintains neutral whites but enhances the dull, dry green of lodgepole pine needles. The summer greens in Velvia can sometimes be outrageous, but they are nice in the winter. Sensia 100 and Provia 100F are both good for wildlife. They push well one or two stops if necessary, and they are usually fast enough with f2.8 or f4 lenses.

The two main problems in winter photography are the cold temperatures and the extreme contrasts between bright snow and dark objects like bison. Exposing for snow involves two basic decisions. The first is to meter the important element properly, and the second is to compensate for white snow. Set the aperture and shutter speed by metering on the most important feature in which you want to maintain color or texture. Film cannot see the contrast that our eyes can, so expose for the important highlight and let the lighter and darker areas go wherever the film puts them. Fill flash, split neutral density filters, reflectors, etc., are excellent tools, but I don't want to carry most of this stuff so there are no examples of those techniques in this book.

The best examples of exposure decisions are found on page one and page eight. The bison on page one is a black silhouette because I metered for the snow, making the snow the most important highlight. On page eight I made the bison the important highlight and metered for him to keep the color and texture on his body. The snow's texture is nearly all gone because it was overexposed.

To make snow appear white and still show the texture, override what your meter says and overexpose it. Exposing snow exactly as your meter says will produce snow that looks like blue-gray sand. If there are shadows in or around the subject, overexpose by 2/3 to 1 f-stop. If there are no shadows, overexpose by 1 to 1 1/2 f-stops. Bracketing exposures is a smart thing to do until you know exactly how your meter reads.

I keep my equipment inside plastic bags when going from cold to warm areas and when travelling through steam in thermal areas. Moisture condenses on cold objects in a warm environment. The moisture on the outside of a camera or lens is a minor problem, but moisture that gets inside can fog up a lens for hours and may short out electronic circuits.